THE MUSIC OF
JOHN LENNON

CHRIS WADE

THE MUSIC OF JOHN LENNON
by Chris Wade

Wisdom Twins Books, 2017
wisdomtwinsbooks.weebly.com

Text Copyright of Chris Wade, 2017
Cover art by Linzi Napier

All rights reserved. No part of this publication may be reproduced, stored in a retrieval system, or transmitted in any form or by any means, electronic, mechanical, photocopy, recording or otherwise, without prior written permission of the copyright owner. Nor can it be circulated in any form of binding or cover other than that in which it is published and without similar condition including this condition being imposed on a subsequent purchaser.

THE MUSIC OF
JOHN LENNON

"John, like many great geniuses, was completely his own man. He was always completely genuine and honest. He saw everything with new eyes and I think his great gifts were sometimes a heavy load for him to carry. What I remember most was that he was a good friend that I had a lot of fun with while I had the privilege of witnessing him create some of the most important music of the 20th century."

- Dan Richter to the author

INTRODUCTION

It's strange to think that had he not been murdered, John Lennon would be 76 today. That's nearly double the age he was when he was taken from us, oh so young at 40, the advent of middle age. The saddest part of it all is that John was genuinely happy for the first time in his life, content with his wife and soul mate, Yoko Ono, and his young son Sean. Life at the Dakota building in New York was good. True, he hadn't recorded much music in the latter part of the 1970s, but being househusband (his phrase) gave John a real purpose in life. other than rock and roll. However, it was at the very start of the 1980s when John ventured back into the studio after a few years on hiatus, to cut Double Fantasy, that he was murdered in cold blood.

The music Lennon left behind is undoubtedly some of the finest in the history of rock and pop, as well as some of the most openly human. He bore it all for us; his flaws, his love, his thoughts, his feelings, his anger, his passion. It's all there in the work, right from the debut Beatles LP Please Please Me, through his varied solo work,

the Imagine album and beyond. This kind of honesty was always rare, but is much rarer still these days, in an age of PR overload and manufactured, money minded goals. Lennon didn't care if you loved him or hated him, as long as you noticed him. And that discography, both solo and Beatles, is unrivalled. Consider the early rock and roll thrills of the first few Beatles records; his sneaking melancholia on A Hard Day's Night and Help; the subtle confessions of Norwegian Wood on Rubber Soul; the spaced out experiments of Revolver and Rubber Soul; the proto acoustic punk of the White Album; his avant-garde trilogy with Yoko, starting with Unfinished Music No. 1; his first proper solo album, channelling his inner emotions on Plastic Ono Band; changing the world on Imagine; establishing himself as a counter cultural outlaw on Some Time in New York City; putting his favourite form of art on a pedestal for Rock and Roll; his stance as an experienced, got-through-it-all love troubadour on Double Fantasy and Milk and Honey. We're talking around 20 years here - quite a musical journey to say the least, and all of it in the glaring eye of the public.

Lennon's music (and his writing too, let's not forget) means something different to everyone, but most can agree upon the raw emotion he expresses on nearly all of his work. You get the sense that he means every word, plays every note with conviction, and puts his all into this art of his. This book explores John's recording career, from the start of the Fab Four, to the end of his short life. Along the way I had a few words with some folk who knew him. Combining the eye witness accounts with my own humble understanding of his work, I feel this book defines Lennon as best as one can, as an artist and man who lived through his music.

JOHN LENNON AND THE BEATLES: THE EARLY YEARS

The early musical influences of each individual Beatle were reflective of the times and fairly typical of any young guy in the 1950s with an interest in popular music. Coming from working class Liverpool, the boys all dreamed of being rock stars in one way or another, fantasising of playing rowdy concerts to packed houses, with screaming girls and general hysteria. In the world of show business however, the odds were stacked against the working class (let's face it, they still are), but for The Beatles and the other bands who made it in the decade following the explosion of rock and roll, it was hard work and honest uphill graft that got them to the top. The Beatles cleared the way for other guys just like them (The Kinks for example), people from ordinary backgrounds without the financial back up of well-off parents to support them.

John Lennon, born in October of 1940, was raised by his Aunt Mimi, after his father Fred disappeared out of the picture and his mum handed responsibility over to her somewhat prim and proper sister. Although people believe he was the roughest of the band, he actually lived in a cosy lower middle class house in a fairly pleasant area. Still, he was definitely rebellious and perhaps the conventional nature of his guardian only forced him to be more of a reactionary figure. His mother played the ukulele, was very musical, and always encouraged John to pursue his creativity. She may not have been a conventional full time mother, but she certainly had a big influence over him, helping form the basis of his future musical capabilities.

"I never thought of being a musician until rock and roll," Lennon later said, adding "rock and roll changed my life." His mum had taught him the banjo firstly when in his teens and the young John naturally progressed on to the guitar as his love affair with rock and roll began. John later said there were no really good British rock and roll records released in the fifties, save for early Cliff Richard and the Shadows singles (although the band disliked the later Cliff and his Christian image), and most of his influences were American, the charismatic Elvis Presley being the most predominant of these. Forming his own group in 1957, The Quarrymen (named after the school the band members all went to, Quarry Bank School) were a primitive affair, but even early on in his musical adventures (as evident on those Church fete live pictures), he was a magnetic character. In many ways he was born to be a rock star. "I always knew I was a genius," Lennon later said, adding "if there is such a thing as a genius, then I am one."

Although the band had a line up, it was irregular and not set in stone. His first new recruit for The Quarrymen then, who actually seemed to be more serious about the group, was Paul, who he met in 1957. James Paul McCartney was born in 1942 to Mary, a midwife, and Jim, a cotton salesman. An amateur musician in his own right, Paul's dad always had instruments around the house and would play the upright piano when Paul was growing up. With his own jazz band and a fondness for old music hall and vaudeville, Paul's father definitely had eclectic taste and an influence over his son. But Paul was a rock n' roller too.

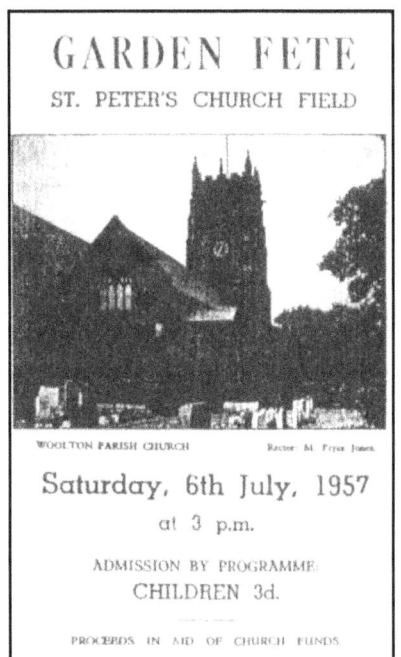

Years later, Paul remembered coming into the fete that day and first setting eyes on Lennon. "I remember coming into the fete and seeing all the sideshows. And also hearing all this great music wafting in from this little Tannoy system. It was John and the band. I remember I was amazed and thought, 'Oh great', because I was obviously into the music. I remember John singing a song called Come Go With Me. He'd heard it on the radio. He didn't really know the verses, but he knew the chorus. The rest he just made up himself. I just thought, 'Well, he looks good, he's singing well and he seems like a great lead singer to me.' Of course, he had his glasses off, so he really looked suave. I

remember John was good. He was really the only outstanding member, all the rest kind of slipped away."

George Harrison, born in 1943 and the youngest of The Beatles, was recruited in 1958, somewhat reluctantly. Paul was keen to get his young friend into the group, but John was doubtful of the squirt's abilities. When Harrison showed him what a flashy player he was, replicating the classic fifties rock and roller Raunchy for him to perfection, he sealed the deal and became a full time Quarrymen member.

Ringo Starr, born Richard Starkey, was a little older of course (born in 1940) and as the Quarrymen honed their style in their own little world, he was immersing himself in his broader musical tastes elsewhere. He started a musical friendship with friend Roy Trafford and the pair of them practised crude skiffle music together; their act consisted of Ringo making noises on a box while Trafford played guitar. By 1959, Starr was a member of Al Caldwell's Texans, a more polished skiffle group with whom Ringo played an *actual* drum kit and adopted his legendary nickname. In 1960 he secured the role of drummer for one of Liverpool's top bands, Rory Storm and the Hurricanes, by far a more well known and accomplished band than The Quarrymen.

In this era, each Beatle was finely tuning their signature styles, although they didn't know it; all the while still worshiping and emulating their favourite stars. The largest musical influence over all four Beatles has to be Chuck Berry; not only did they cover a lot of his songs in the early days of The Beatles (as any self respecting "beat" band did), they also took inspiration from his chord structures

and solos. George especially played a mean solo like Berry, long before his guitar work became more imaginative later in the 1960s.

One of the biggest influences on the group, heavily evident on the earlier Beatles work, were the Everly Brothers. Indeed, John and Paul did a fine job of emulating those bittersweet, close harmonies and this is even clear on the band's 1958 demo (recorded at Phillips Sound Recording Service in Liverpool), where they take on Buddy Holly's That'll be the Day and In Spite of all the Danger, the latter an early, surprisingly brilliant McCartney number.

The Quarrymen went through various name changes and spelling alterations around this time, like The Beatals and The Silver Beetles, yet to settle on their legendary moniker. The Beatles name first came up when the lads were talking about Buddy Holly and the Crickets, and wanted to come up with a similar insect like name as a kind of homage. John says it was he that added A into Beatles, as a pun on the beat music boom at the time. They did have a more solid line up by then and a musical chemistry was definitely beginning to show itself. John's art school friend Stuart Sutcliffe was also on board, playing the bass for them in this era; although his presence often caused friction, as Paul has claimed to have been jealous of Lennon and Sutcliffe's friendship. With Tommy Moore briefly on the drums, they went on a tour of Scotland as the back up band for rock star Johnny Gentle. It was a short jaunt, which paid very little. But it did lead them to their next engagement - a residency in Hamburg, Germany.

Stories of The Beatles' escapades in Hamburg reveal that the band were far from the goody two shoe loveable mop tops that manager Brian Epstein and the media made them out to be. Someone once

said that they went to Hamburg as boys and came back as men and judging by the various accounts of their time there, we can see that much is true. Coming over from Liverpool, sent by gig promoter Allan Williams, the lads really learnt their trade at the sleazy German clubs. Spending time with hookers, gangsters and strippers, The Beatles took pills to get through the long working nights, and they lived and slept like beggars, using flags for duvet covers while dossing in the back room of a cinema. "It was a pig sty," Lennon later said. "We were right next to the ladies' toilet." The music they played there was pure high energy rock and roll, sweaty and unsophisticated yes, but judging even by the few recordings from their time there, it was also very exciting.

The December 1962 recording of the band at the Star Club has been released and re-released numerous times over the years and while it's a little rusty in its sound quality, it's also an invaluable glimpse into their embryonic early years. They had played the brand new Star Club firstly in April of 62 for seven whole weeks' residency. Before this they had earned their chops playing at the Indra Club and Kaiserkeller for countless grotty nights.

When Williams had first sent them over, they had no permanent drummer, so McCartney speedily looked around for someone to sit in on the skins. Somehow, they had been doing OK without a permanent drummer and no one had really batted an eye lid. (McCartney's line to doubters was "the rhythm's all in the guitars.") After Tommy Moore had left the scene, they found Pete Best and went out to play the Indra Club in the shadiest area of Hamburg.

Pete Best was a Liverpool celeb in his own right. "Liverpool was the centre of the universe for a period of time in the sixties," Pete told me

a few years back. "Liverpool has always had a very healthy music scene. It has produced great groups, but the Liverpool scene of today cannot be compared to what was happening back in the day. Live music was king! I met them (The Beatles) at my mother's club, the Casbah Coffee club in 1959. John Lennon, Paul McCartney, George Harrison and Ken Brown opened the Casbah on the 29th of August, 1959. They were the Quarrymen then."

Although Stuart Sutcliffe was still on bass at this point, some have claimed he couldn't play that well and was basically there to keep the numbers up and originally to ease any suspicions about the band not having a bass player. (This was before Paul switched to bass obviously.) While there, the band became friendly with two hip Germans, Astrid Kirchher and Klauss Voorman. Speaking years later about the first time she saw the group, Astrid said "It was like a merry-go-round in my head, they looked absolutely astonishing... My whole life changed in a couple of minutes. All I wanted was to be with them and to know them." They played mercilessly long sets to rough crowds, who they eventually won over, becoming known as "the crazy Beatles" for their outlandish on stage antics, according to Pete Best.

How would Pete describe an average day in Hamburg? "Wake up, feel exhausted, wash and go and eat. Replace drum sticks and guitar strings. Go to club, perform for 8 hours. Drink. Go to bed. Wake up, feel exhausted, wash and go and eat. Kinda like that." He says he felt closest to John. "We shared our inner thoughts," he told me.

One chap who came to see the band, when not drumming with his own band Rory Storm and the Hurricanes that is, was Ringo Starr, who enjoyed the band's later sets when there were less punters

around. It was by then that things were winding down a little for the night and The Beatles played more obscure pieces, B sides and oddities, mostly for themselves. Ringo thought they were great.

In 1961, The Beatles backed singer Tony Sheridan on the legendary My Bonnie single, a minor hit in Germany that later became more popular once The Beatles were getting a big following in Liverpool. Of course, they weren't credited as The Beatles - they were naffly called The Beat Brothers on the original sleeve. But the single caught the attention of NEMS record store owner Brian Epstien, who was branching out into music management and looking for acts. Once the band were back in the UK (Sutcliffe stayed behind of course and later died way too young at the age of 22 of a brain haemorrhage), Epstein decided to check them out at the Cavern. He thought they were rusty, in both appearance and in sound, but admitted they definitely had something. The band's seemingly effortless knack of gelling with the crowd and indeed gelling as a group was as a result of their experiences in Hamburg, winning over the brawling drunkards. As a result, Liverpool seemed tame in comparison.

By the end of 62, as evident in the recorded live set at the Star Club, The Beatles had definitely tightened their repertoire. With Paul on bass, Sutcliffe out of the picture, Pete Best sacked and Ringo firmly on the skins, armed with a host of great songs, the band sound urgent and full of fire. They quickly went on to bigger and greater things of course, due mostly to good old fashioned hard work, yet there was something so raw and enthralling about that proto-punk sound that left their recorded output once they took on their new commercial image. John always insisted The Beatles played their best music in Hamburg, night after night, week after week, high on pills and

sweating gallons. "Our best stuff was never recorded," said Lennon, forever the great rock and roller through and through. You can't help but ponder...

The Beatles did go back to Hamburg in 1966, only they didn't sleep in a grotty back room together with flags for bed sheets. They played Ersnt Merck Halle. During a press conference upon arrival, the lads were in cheery spirits. "Do you think your time in Hamburg has been important to your career?" they were asked by a reporter. "Yes! Because it was just very good," replied Paul, "and we played a lot and it was good for us. And the people were a good audience." The next question took them by surprise.

The band's success was not an overnight explosion as some people may think. Liverpool legend and founder of Mersey Beat Magazine Bill Harry was there from the start. "I introduced John to Stuart in Ye Cracke when Stu was there with his best mate Rod Murray," Bill told me in 2015. "The four of us were to become the Dissenters – with a vow to make Liverpool famous: John with his music, Stu and Rod with their painting and me with my writing. With us, he was keen to join the discussions about art and literature and we'd all go to pubs and coffee bars together. He showed another side of his character when he went out with his other two mates, Tony Carricker and Geoff Mohammed and they all got up to mischief! Since Paul and George were next door at Liverpool Institute and rehearsed in the college rooms, chatted with us in the college canteen and played at our college dances, I encountered all of them at college."

From here, it was onwards and upwards, and the beginning of the Beatles legend.

THE EARLY BEATLES ALBUMS: JOHN THE LEADER

Given that so much praise is heaped upon the mid to latter period of The Beatles' career for its innovative sonic advancement, it's something of a revelation when you really listen again to those early, more primal albums and hear just how tight, arresting and unique they always were. You have to remember, fifty years down the line with them cemented as the greatest group that ever existed, that this is the music the world originally fell in love with. If not for these early records, the myth of The Beatles and the globe's ongoing love affair with them would not exist.

As Paul McCartney counts in the band at the opening of I Saw Her Standing There, he is in effect counting in a totally new era, a fresh decade where The Beatles would be at the forefront of music, fashion and celebrity culture. It was a time when those four lads would kick the world up the backside and bring it out of its post-war slump. As

George Harrison once said, The Beatles saved the world from boredom. Of course, he also noted that the world used them as an excuse to go nuts, and I think he had a point. Things were stale, and even though it was nearly 20 years since the end of the Second World War, Britain hadn't quite found its feet again. In some ways, Britain had been living in black and white before The Beatles came along and made it colour. After the assassination of JFK in 1963, America was wounded and had lost all hope. The Beatles, with their lovely music and fun attitude, were just what they needed to fill that saddened void. Rock and Roll had arrived earlier of course, but it had divided the generations even further. Grown ups either couldn't get it, didn't see what the fuss was about or were downright appalled by the hip swinging antics of Elvis and company. The fantastic thing about The Beatles was that they brought these ages closer together. There was something for everyone in the band's music and combined personalities. As millions of families gathered around their TV sets for that earth shattering performance on The Ed Sullivan Show in February of 1964 (undoubtedly the moment they became the biggest stars in the world), The Beatles united all walks of life and kick-started a cultural shift that everybody could be a part of.

It's kind of mysterious now to ponder on why this band captured the hearts and imaginations of the whole world, but maybe it's because they appeared just at the right time. Their producer George Martin said that when he first met them a lot was to be desired and they weren't that impressive as musicians or songwriters. Although they were never technically virtuosic, they had a charm and charisma that went beyond the ballsy rock and roll they were playing at the time. It was a whole package kind of situation; great songs, catchy

hooks, tons of personality and good old fashioned British humour. The Beatles had a bit of everything, appealing to fans of all ages and types. It's this reason why we'll never see anything like them ever again.

The band's first album, Please Please Me, sets the ball rolling for their recording career and although it's quite a safe album in regards to their later work, it's easy to see why the world got so excited by them. Album opener I Saw Her Standing There is a cutting slice of ballsy teenage thrills, with sharp, precise chords at either side of the listener, loose drums and close harmonies transporting us back to the

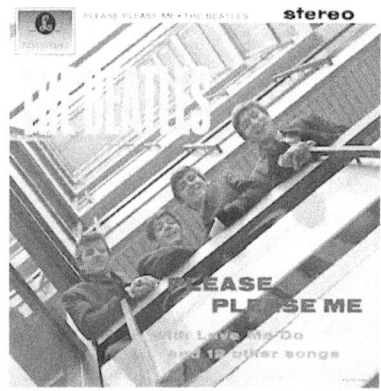

dance floors of the sixties. A sturdy Ringo back beat drives along this tale of sheer lust, sung with gusto by a youthful and fresh McCartney. Although Lennon was seen as the leader of the group at this stage (he later said that he knew he dominated this era), and indeed for the early segment of their career seemed to be the main force, McCartney still shone brightly when put into the spotlight.

Thought up by McCartney on the way back from a gig, it was firstly called simply Seventeen before the full lyrics were shaped out. "I wrote it with John in the front parlour of my house in 20 Forthlin Road," Paul later said in Mark Lewisohn's brilliant Complete Beatles Recording Sessions book. "We sagged off school and wrote it on guitars and a little bit on the piano that I had there." On the Beatles documentary Anthology, Paul highlights the way he and John would

collaborate on lyrics even at this early stage. "We were learning our skill," Paul said. "John would like some of my lines and not others. He liked most of what I did, but there would sometimes be a cringe line, such as, 'She was just seventeen, she'd never been a beauty queen.' John thought, 'Beauty queen? Ugh.' We were thinking of Butlins so we asked ourselves, what should it be? We came up with, 'You know what I mean.' Which was good, because you *don't* know what I mean."

The next two tracks have John at centre stage, taking most of the lead on Misery. They had originally penned the track for a planned album by Helen Shapiro, but thankfully they decided to record it themselves. John's voice pairs with Paul's quite beautifully, yet charmingly roughly so at points. The arrangement is exuberant too, despite the depressed lyric. John later said that although they wrote it

together, it was definitely more of a John song. Listening closely, this much is evidently clear. Think of the anguish on later tracks like Help! and I'm A Loser; John had a firmer grip on the more raw and anguished sort of lyric than Paul ever did and was attracted to exploring the darker side of life and love, even on the supposedly lighter material of their earlier years.

Then it's the superb Anna (Go With Him), originally written by Arthur Alexander. Lennon's voice is at its best on these early records, passionate, fiery and full on. There's a real crunchiness to the band too; the loose drums, the thumping bass and jagged guitars. Chains,

written by Carole King and Gerry Goffin, has a lead vocal by Harrison, his first moment up front on the record. The music bounces along nicely, but it's clearly more of a filler than anything weighty.

Ringo gets his first lead vocal of the band's discography, giving a fine performance on Boys. Again though, Lennon seems to dominate proceedings, singing lead on Ask Me Why, which boasts a wonderful melody and some trademark Beatle harmonies. There is a lot of emotion in Lennon's voice, both pained and lustful, and it's his performance that's the main element drawing you in. He pairs up with Paul for the classic title track, Please Please Me, a real stand out among the other numbers, showing that within the covers they had chosen, their original penned songs were unarguably the strongest. It has "hit" written all over it, and structurally is a kind of smooth merge of Roy Orbison and Buddy Holly. It's one of the first instances where we hear those classic Lennon and McCartney vocals working together at their tightest, harmonies so close it's as if they're coming from the same mouth.

In one of his final interviews, John spoke of the track. "Please Please Me is my song completely. It was my attempt at writing a Roy Orbison song, would you believe it? I wrote it in the bedroom in my house at Menlove Avenue, which was my auntie's place. I heard Roy Orbison doing Only The Lonely or something. That's where that came from. And also I was always intrigued by the words of Please Lend Your Ears To My Pleas, a Bing Crosby song. I was always intrigued by the double use of the word 'please.' So it was a combination of Bing Crosby and Roy Orbison."

The song was also a hit single for the band, reaching number one on some charts but number two on the "official" one that the history books seem to go by. Although still very much a pop song with little meaning, it's a sincere number and the lyrics are still clever to this day.

Love Me Do is another gem (their first single, but only a minor hit in the UK), and in my view quite possibly the highlight of the whole record. With its influential, genre redefining reputation aside, it's a thumping little slice of gutsy rock n' roll. John and Paul take the vocal on together with strength, mixing their tones superbly and Paul delivers the chorus line as John grinds away on the harmonica. The bass and drums bang on tightly, creating a solid groove together. It's one of the first truly brilliant moments on a Beatles record and it still sounds genuinely fresh today. It's also a song that happened to have a big impact on a lot of future musicians, who cited it as a turning point in their lives upon hearing it on the radio. For them, it was the moment they realised they too might be able to have a chance at being a rock and roll star.

Love Me Do really was a turning point for the band and its success wasn't just down to record company hype. Cast yourself back to 1962; what would you have made of this song, thumping out of the speakers at you? Even McCartney, years later, admitted the song was a big turning point for them. "In Hamburg we clicked. At the Cavern we clicked," he said. "But if you want to know when we 'knew' we'd arrived, it was getting in the charts with Love Me Do. That was the one. It gave us somewhere to go."

Harrison sings lead again on Do You Want to Know A Secret, a beautiful, sweet song with some interesting chord shifts. The song hit

number one in the US and number two in the UK, although it's best enjoyed when nestled in the middle of this album. It was in fact written mostly by John, inspired by the song I'm Wishing in the Disney version of Snow White and the Seven Dwarves, which his late mother would sing to him when he was a boy. This really gives it a slight air of sadness, but it's also very moving and sincere when considered in that light. (Note that the echo on the backing vocals makes the lads sound like they are singing down a well, as Snow White does herself in the movie.)

It's unusual for such a personal song not to be sung by John himself, but he explained this in a 1980 interview. "Well, I can't say I wrote it 'for' George. My mother was always... she was a good comedienne and a singer. Not professional, but she used to get up in pubs and things like that. She had a good voice. She could do Kay Starr. She used to do this little tune when I was one or two years old... she was still living with me then. The tune was from a Disney movie. So, I had this sort of thing in my head, and I wrote it and just gave it to George to sing. I thought it would be a good vehicle for him, because it had only three notes and he wasn't the best singer in the world. He has improved a lot since then; but in those days, his ability was very poor."

Baby It's You, written by Bacharach and David, is given the Lennon treatment with some fine backing vocals from the boys, although it's not as strong as their self penned numbers, which they take on with more energy and imagination. There's A Place is a nice moment, a breezy bit of pop that features some tidy melodies. The band arguably saved the best until last though, or at least the loudest; their monstrous version of Twist and Shout, with a screeching Lennon

bringing the set to a close powerfully. The heavy guitars rock away, the bass pumps and the drums are steady beneath one of John's best ever vocal performances. While many others have recorded the song, you wouldn't be misguided in saying that The Beatles' version is the definitive recording. It bursts out of the speakers, and is incredibly powerful even today in its primal instructions; to basically freak out a bit and let loose.

"That record tried to capture us live," John later said of the record as a whole, "and was the nearest thing to what we might have sounded like to the audiences in Hamburg and Liverpool. You don't get that live atmosphere of the crowd stomping on the beat with you, but it's the nearest you can get to knowing what we sounded like before we became the 'clever' Beatles."

There is certainly still a lot of enjoyment to be had on this record and the fifty odd years since its release haven't dimmed the contents at all. It's a brilliant snap shot of a time and perhaps the perfect artefact to sum up the early appeal of The Beatles. It's lyrically quite corny at times, but the music is always powerful and cleverly executed. When you consider they were in their early twenties at this stage, it's all the more remarkable that the chord structures and harmonies are so intelligently thought out and delivered. Besides, there was a naivety in popular music at the time that genuinely appealed to the young, those unspoilt by the pressures of adult life, and The Beatles lyrical content was no different. There's something joyous about the band's approach to the love song, their clever twisting of words and phrases, and the passion behind their playing. It's little wonder the kids found them so exciting.

At this point, the band were still mostly playing straight rock and roll, and George Martin kept things poppy and commercial with very few risks being taken. But even with this said, their music was still much more sophisticated and smart than that of their contemporaries. It was a pop album for 1963, or more to the point, THE pop album of 1963, an important factor in making them stars all over the world. Please Please Me may still be a strong album, but it's merely stage one on their journey.

In the fickle, fast moving pop music world of 1963, names came and went as quickly as they had arrived. In a bid to capitalise on their fame, the band were forced back into the studio by Parlophone that same year to cut their follow up album, With The Beatles. Surprisingly, considering how quickly it followed up their debut record and the band's hectic schedule at the time, the resulting album is among their early best and still packs a whopping punch to

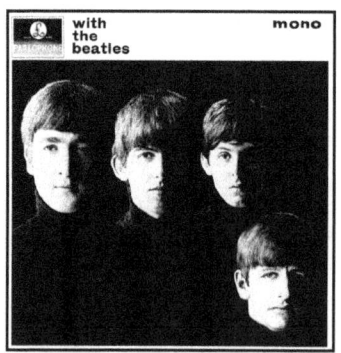

this day. In fact, it's probably more enjoyable than their debut, showing how speedily they had progressed in a few short months.

It all starts with the resounding elation of It Won't Be Long, with a frenzied Lennon on full force reaching out to the one he loves.

Again, it's high energy rock and roll, a sure fire hit sound for the band, and they groove along as a unit with perfection. At this stage, they were already well into their world domination and this is the sound of a band on top. Lyrically the song is interesting and an example of their love of messing with language, with its word play

on "be long" and "belong." Musically, it's exciting and the youthful energy is very appealing. The best thing about it though are those wonderful harmonies, the desperate "yeah" after each delivery of the chorus line. It was these little touches that made the band's material more interesting. "It was only after a critic for the Times said we put 'Aeolian cadences' in It Won't Be Long that the middle classes started listening to us," John told Playboy in 1980. "To this day, I have no idea what 'Aeolian cadences' are. They sound like exotic birds."

It's quite fitting that John's intelligent turns of phrase, both lyrical and musical, were purely natural and almost accidental. Had he had formal training, or even understood song structure as an art form, the songs would never have come out like this. This is primal, but also very clever. Written by a man in his early twenties, who cut his teeth on sweaty hard rock and roll in Hamburg, it's remarkable how speedily his song writing talent took off.

All I've Got to Do is a nicely written and executed track, with another strong vocal from John (emulating Smokey Robinson, in his own words), although it's a little rough around the edges. The drums are nice and loose, actually giving the song its real power when you listen closely. Elsewhere, it's standard early Beatles fare, rarely picked out as a favourite.

Paul's first step out to lead vocal duty is the wonderful All My Loving, among the very best songs on the record. It features a warm and affecting performance by McCartney addressing the female members of the audience, although the blokes can still enjoy it too. The band give this one a great groove, the guitars speedy and restless, while the drums are loose and the energy is liberated. Paul said it was the first track he ever wrote with the words coming before

the music, while John always loved it and regretted having to give full credit to Paul. "I play a pretty mean guitar in the back," he added later. There's something about this song that really sums up the beautiful days of Beatlemania.

One stand out moment for me is George Harrison's first song for the band, Don't Bother Me, an underrated slice of paranoia and isolation amidst the more standard pop love songs on the album. It was something of an experiment for George, who just wanted to see if he could actually write a song all by himself. Of course he could and this is one of the best on the record.

Little Child is a solid number, with some great vocals and harmonies by Lennon and McCartney punctuating a rich and full musical backing. John and Paul later said it was nothing more than "a work song," but that doesn't damage my enjoyment of it, as I feel it's a cracking little song - and when I say little, I really do mean little, as it's only 1 minute and 46 seconds long. It was originally intended for Ringo to sing it, but in the end John and Paul took it together.

John rocks it solidly on Please Mr Postman, another song that's been recorded countless times, but one that I feel The Beatles cut the best rendition of; although this is arguable of course, as there's been some fantastic versions of it over the years. The Beatles used to play the song at the Cavern in the early days, so it was inevitable they were going to add it to a record if they were running low on their own numbers.

Paul later spoke of the band's decision to record it. "Influenced by the Marvelettes," he said, "who did the original version. We got it from our fans, who would write Please Mr. Postman on the back of

the envelopes. Posty, posty, don't be slow, be like the Beatles and go, man, go! That sort of stuff."

George takes lead vocal on a fine version of Chuck Berry's classic Roll Over Beethoven, with The Beatles giving it some genuine energy, chugging away on bluesy power chords. Despite some rushed and ragged guitar solos from George, it's still a decent version. Paul gives a great rock and roll performance on Hold Me Tight, his and John's take on the classic 1950s rocker format. It had originally been written in 1961 and they attempted to record it for Please Please Me to no avail. Although both John and Paul never regarded the song as anything special (Paul called it another one of his "work" songs and Lennon called it poor), it drives the album along nicely, with some neat drums and heavy guitar work.

The band's version of You Really Got A Hold On Me is a highlight from the early era, moody piano and nice lead guitars lending themselves to classic Beatle harmony heaven. The voices do sound fantastic and George Martin really captured them brilliantly here. The band would resurrect the song at the Let it Be rehearsals, when their inspiration was running low on new material, although they sounded nowhere near as tightly knit as they do here.

The single they gave away to The Rolling Stones, I Wanna Be Your Man, is here passed over to Ringo for his obligatory lead vocal moment. In truth it's a fantastic version, for me much better than The Stones' rendition, with a solid Starr aided by the band with the simple yet effective lyric. The music really rocks, all grinding guitars and loose hi hat. Although seen as filler by Lennon and McCartney, it's something of a favourite of mine. In 1980, Lennon spoke of the decision to give the track to the Rolling Stones. "It was a throwaway,"

he said with honesty. "The only two versions of the song were Ringo and the Rolling Stones. That shows how much importance we put on it: We weren't going to give them anything *great*, right?"

Lennon's Not A Second Time would have been a better contender for the album closer then their cover of Bradford and Gordy's Money, which although good, is not among the album's strongest cuts. The choice of covering Money was valid though and again The Beatles cut what I feel to be the definitive version - although the understated Flying Lizards version is also a classic. However, it was Not A Second Time that drew serious praise from the media and helped towards the band being accepted as serious writers of sophisticated music, rather than just pop stars singing to their adoring female fans. It was at this point the intellectual establishment began to pile on the praise, no longer able to brush The Beatles off as a pop fad. With the Beatles was the first pop album to sell over a million in the UK, so this had to be taken seriously now. Although still firmly in the pop field, it was clear that The Beatles were progressing in their songwriting and composing skills, even if their development was more natural than conscious.

Of all the early Beatles records, A Hard Day's Night is the one where it's clear that Lennon was by and large the leader of the group. It's obvious throughout that his role in the band is much stronger, taking on most lead vocal duties, backed up of course by Paul who handles the higher sections and harmonies which John's voice couldn't quite reach. It's old fashioned fast paced rock and roll for the most part, something Paul and John both enjoyed, but perhaps a genre which John was more willing to stay within the established comforts of.

Separating the music from the Hard Day's Night film is not easy, with those vibrant, energetic images of the band running down the street from screaming fans racing through the mind. Indeed, this album as a whole is probably the one that really sums up the hysteria of Beatlemania in its full bloom the best. Yet despite the magic, there was still an inkling that what The Beatles were doing was product to sell to their public, especially in the eyes of Lennon, who could separate a work song from one that genuinely came from his heart. Given that songs were written on demand especially for the movie, you can feel Lennon's point of it being business as usual. Still, there are enough stand alone solid songs to please the listener, even though retrospectively many will be waiting for the band to arrive at their more substantial and experimental material.

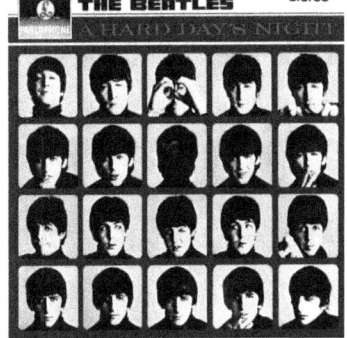

The album opener and title track has become one of the key Beatles songs, a musically upbeat but lyrically knackered number, with Lennon taking on the lead vocal and Paul on reliable middle eight duty. The Harrison guitar solo is one of his finest and the whole song is played with thorough enthusiasm by the group. Ringo's drumming is loose and simple, enhancing the excitement further. The title itself had come from a remark Ringo had casually made, something he did all the time in those days. "We went to do a job, and we'd worked all day and we happened to work all night," he recalled. "I came up still thinking it was day I suppose, and I said, 'It's been a

hard day...' and I looked around and saw it was dark so I said, '...night!' So we came to A Hard Day's Night."

"I was going home in the car and Dick Lester suggested the title, Hard Day's Night from something Ringo had said," Lennon said in 1980. "I had used it in In His Own Write (John's hilarious book of nonsense verse) but it was an off-the-cuff remark by Ringo. You know, one of those malapropisms. A Ringo-ism, where he said it not to be funny... just said it. So Dick Lester said, 'We are going to use that title.' And the next morning I brought in the song... 'cuz there was a little competition between Paul and I as to who got the A-side - who got the hits. If you notice, in the early days the majority of singles, in the movies and everything, were mine... in the early period I'm dominating the group. The only reason he sang on A Hard Day's Night was because I couldn't reach the notes. (sings) 'When I'm home/ everything seems to be right/ when I'm home...' - which is what we'd do sometimes. One of us couldn't reach a note but he wanted a different sound, so he'd get the other to do the harmony."

It's a definite progression for the band, although musically it sticks to a similar style they had already been perfecting on the last two albums. It's the lyrics that are clever though, the play on words element they were so good at and the creeping in of the classic Lennon neurosis. The song also captures the constant work The Beatles were committed to; the live dates, the plane journeys, the car rides, the recording sessions - just thinking about it makes you feel shagged out and they really managed to capture the hectic world of The Beatles in this track. The baffling and slightly mysterious opening chord soon became an instant icon in its own right. "We knew it would open both the film and the soundtrack LP," George

Martin told Mark Lewisohn. "So we wanted a particularly strong and effective beginning. The strident guitar chord was the perfect launch."

I Should have Known Better is easily one of the best songs on the album, with its infectious harmonica and signature ringing vocal by John Lennon. There's a relentless punch to the music too, the drums driving it along nicely with solid chords. Although John was later derogatory about it, as he was with much of the classic Beatles material in various bitter press interviews (he said it didn't mean a thing), it's a lovely number and its position within the film, while the lads play on a train surrounded by schoolgirls, is a classic Beatle moment.

If I Fell marked a point where John and Paul became the great love ballad writers of their era, a sublime lyric, melody and vocal sound combining to make one of their early stand outs, although it's clearly more John's song than a collaboration. Its most enduring quality is the gorgeous John and Paul harmonising at their early peak. Paul later pointed out the absurdity of the media and public's perception of John, that he was just the moody rock and roller. "People tend to forget that John wrote some pretty nice ballads," he told Barry Miles. "People tend to think of him as an acerbic wit and aggressive and abrasive, but he did have a very warm side to him really which he didn't like to show too much in case he got rejected. We wrote If I Fell together but with the emphasis on John because he sang it. It was a nice harmony number, very much a ballad."

I'm Happy Just to Dance With You is given over to Harrison on lead vocal and although it's more of a filler, it's still nicely played and enjoyable to listen to. One of the album's best songs is And I Love

Her, a sweet, slightly melancholic classic McCartney love song, the kind he would have to apologise for in the 1970s (notably on a hit single like Silly Love Songs). This is old fashioned stuff, but as Paul later noted, it was George's little acoustic flourish that gave the song its hook and real sense of individuality. That was the great thing about The Beatles; here were four different personalities, perhaps coming from totally different angles, each adding in their own character. Each member felt that the pressures of fame were made easier by the fact there were four of them and often said that they felt a little sorry for Elvis, who had the weight of being "the King" all on his own shoulders. The Fabs could easily understand what each Beatle was going through, and they always had one another to fall back on, musically and personally. In the instance of this track, that is clear and there is a togetherness about the whole thing that makes it pop perfection.

Tell Me Why is another one of Lennon's "black" tributes, a girl group kind of song as he later said. It's a fairly straight forward track though, and not as interesting as the one that closes the first side, Can't Buy Me Love. Becoming one of their trademark singles, it was actually written while the band were staying in Paris and recorded there at EMI's Pathe studio. The song instantly explodes to life, with Paul in fine rock and roll voice, while Ringo loosens up the hat to enhance the energy of the track. There's also a special Harrison solo in there too.

Any Time At All is similar to It Won't Be Long from the preceding album, only it's nowhere near as exciting and fresh. Another loose hi-hatted number, you realise that at this stage it was often Ringo who was giving the songs the manic sense of Beatle energy. One of the

quirkiest tracks is the Dylan-like I'll Cry Instead, a fine Lennon monologue of neurosis. Note Ringo's tight drumming and Paul's flourishes on the bass. Other than that, it's fairly straight forward stuff and ludicrously short at 1 minute 46.

Things We Said Today could well be the best song on the album, with its minor key melancholia and excellently understated Paul vocal. There's a solid back beat and some jangling acoustic guitars to make things interesting musically. When I Get Home is possibly the poorest moment on the album, with John shouting out the weak lyrics. The "wow wow ahh" bits are particularly uninspired and derivative of earlier Beatle gold. The lyrics are clichéd and you can hear John grasping for things to rhyme, with the part about loving her until the cows come home surely ranking as the worst lyric he ever came up with. The playing itself is strangely sluggish too and it's a bit of a relief when the song does end. The Beatles were so overworked that you can understand the song's short comings.

You Can't Do That is much better, another Lennon autobiographical number with some troubling lyrics (threats even), a nice cowbell punctuated beat, gnarly guitars and neat backing vocals. This time the melodies hold the interest and the band are clearly enjoying themselves. John though is a man tortured by his own paranoia, years before he admitted he was a "jealous guy."

I'll Be Back is a sad closing number, all minor keys and regrets, with some nice acoustic guitar that sounds Spanish at points. Lyrically, there's a heaviness to it, and despite what Lennon later called a "tatty middle bit" it finishes the album in a down beat yet appealingly enigmatic manner.

Fifty years on, this is still a fresh and vital album, despite the obvious filler and moments of weakness, at least in comparison to the stand out classics. A Hard Day's Night remains influential and it's still ludicrously iconic. It was another winner for them, as was the movie and a step towards the key Beatles material that reshaped pop.

Beatles For Sale is probably the most muddled of The Beatles' albums in my view, which isn't saying it's in the slightest bit bad - it's quite obviously still a classic - but it sounds a little rushed, at least in comparison to the records that followed it. Of course, the often ragged quality wasn't their fault. After all, that year alone they released two albums, numerous singles, a movie, made numerous TV appearances and gigged around the world feverishly. It's unbelievable really that within a year or so of Beatles for Sale being released, the band would find the energy and time to be pushing musical boundaries and bringing pop to a more "serious" area, where it was taken as real art rather than just "product" to be flogged to kids. Still, there are hints towards it on this enjoyable, yet uneven record.

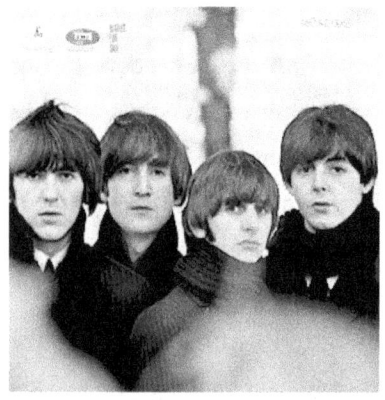

Despite the album's slightly lesser moments, there's some of John Lennon's finest cuts from the band's first half life span. No Reply is a pained, cynical and weary opener for the record, with some wonderful lyrics that sum up the true heartbreak of a former love shunning you outright. Musically, it's absolutely on the money, with gorgeous acoustic guitar strumming conjuring an early Dylan

influence. It's definitely one of the band's best and least likely album openers.

"That's my song," John said a little before his death. "That's the one where Dick James the publisher said, 'That's the first complete song you've written that resolves itself,' you know, with a complete story. I had that image of walking down the street and seeing her silhouetted in the window and not answering the phone, although I never called a girl on the phone in my life. Because phones weren't part of the English child's life."

I'm a Loser is another sad song, albeit against a high energy and upbeat musical backdrop. The Lennon melancholy is starting to show predominantly at this stage and he was certainly maturing as a reflective songwriter. At this point, The Beatles were on the verge of writing deeper lyrics and looking within themselves, and at times it sneaks into the mix. The acoustic strumming again hints towards the band's infatuation (for want of a better word) with Bob Dylan, as on the first song, although the lyrics still concern heart ache and lost love. There's a country and western vibe to the rhythm, especially in Ringo's drumming, and the fact that it differs from the standard rock and roll rhythm makes it very interesting. There's also some nice, unexpected musical detours with a discordant guitar solo and a marvellous harmonica section by John, clearly aping his hero Dylan.

Baby's In Black is a lovely moment on the record, although I prefer the version they played at the legendary Shea Stadium concert in 1965 for its sheer excitement and passion alone. The echo is on for John's take on Chuck Berry's classic Rock and Roll Music, one of his finest rock performances against a solid rhythm section.

There are lesser moments like Mr Moonlight, which I have to admit John still gives some real welly, but there are also undeniable classics like Eight Days a Week, a charming throw back to their first two albums. The song has a startling introduction that instantly conjures up images of childhood (this whole era is nostalgic for me, as it reminds me of when I was very young and my dad was playing the old vinyl constantly), and despite its obvious catchiness and musical merits (the melody is a killer), Lennon seems to have hated the song. That, of course, could have been more of a defence mechanism against showing his inner warmth towards anything Beatles related. "Eight Days A Week was never a good song," he later spat. "We struggled to record it and struggled to make it into a song. It was his (Paul's) initial effort, but I think we both worked on it. I'm not sure. But it was lousy anyway."

If you consider the singles from this era, the band were definitely leaving some of their best work off the full length players. I Feel Fine, a catchy riff driven track (and the first pop song to use guitar feedback predominantly) is one of their best ever singles, featuring a strong Lennon vocal and groovy tom and cymbal led Starr drum beat. had this song been included on Beatles for Sale, it would have been much better. In all though, it's definitely not one of their best albums, but not without its moments of magic either and certainly an important transitional release that led the way to the band's future.

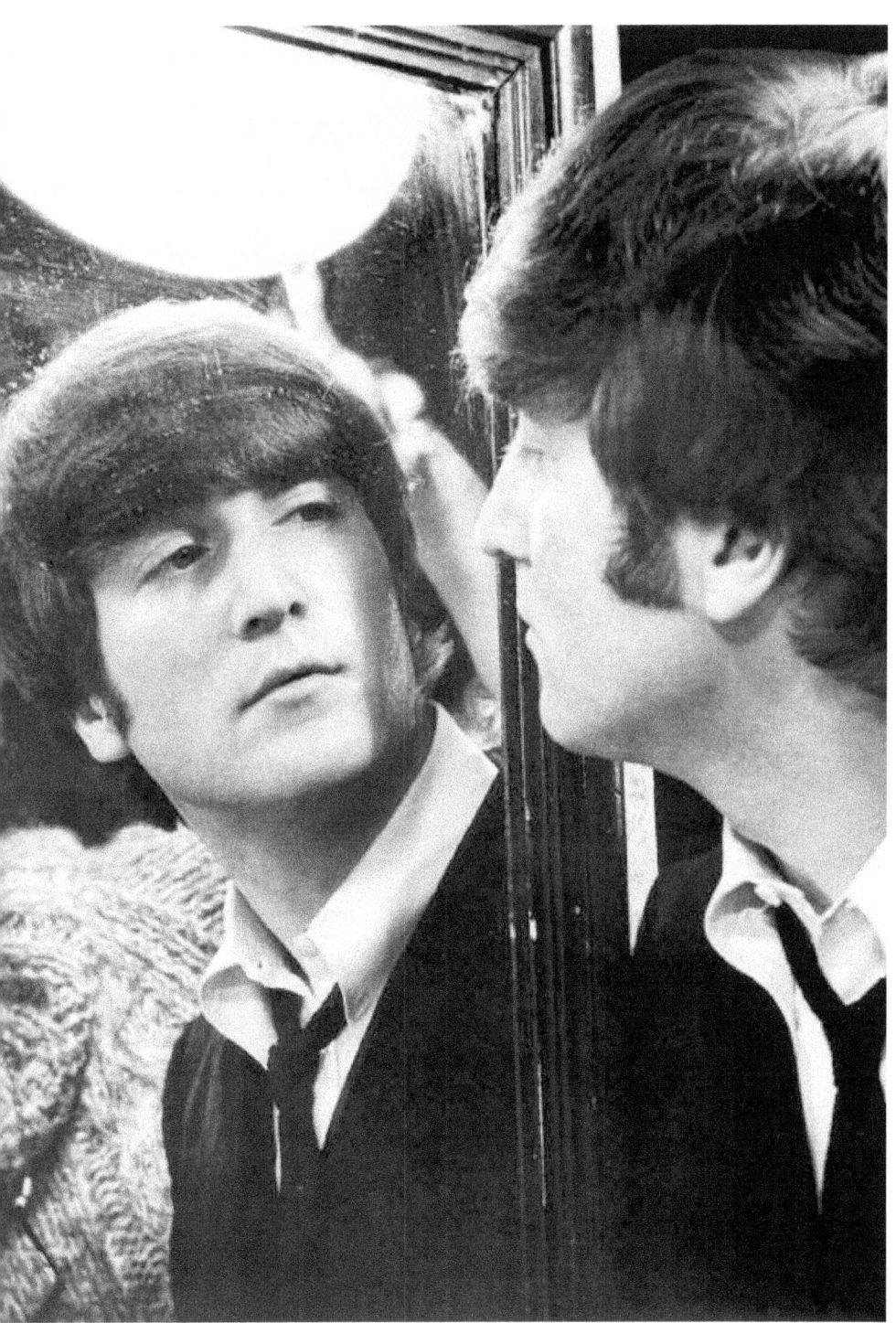

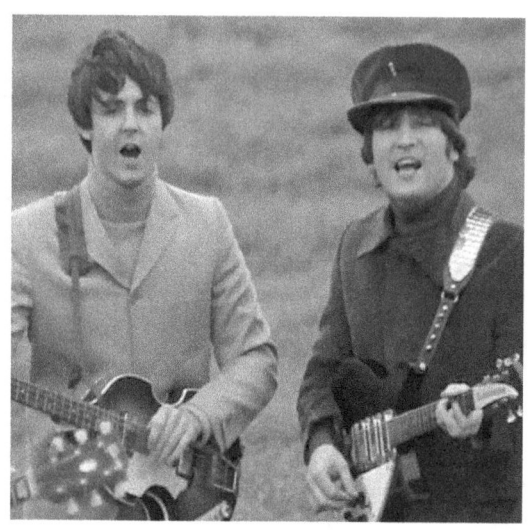

FROM HELP TO RUBBER SOUL

In 1965, things took a drastic twist for The Beatles. Live work was becoming tiresome, and the band couldn't hear what they were playing. The recorded work was becoming more ambitious too, more complex, and more grown up. For me, Help! is the first truly great Beatles album. Yes, the ones predating it are undoubtedly very good, but Help! elevates them to a new level from the word go. As the soundtrack to their second movie, the music acts as a great companion to the film, which was seen as a disappointment in comparison to the lower budget and infinitely more influential A Hard Day's Night. It was evidently clear that the band had told the screenwriter to put ludicrously exotic locations into the script mainly because they fancied going there. Still, I find the film much funnier than its predecessor and although it's broad at times, lacking the documentary feel of A Hard Day's Night, it's full of that Goonish, pre-

Monty Python style humour. Leo Mckern in particular is fantastic as the Indian after the ring that Ringo has found locked around his finger, and Roy Kinnear and Victor Spinetti are brilliant as a pair of inept villains with a preference for German products over British. As great as it is, it's the music that will live on.

By 1965, The Beatles had been turned on to pot and perhaps its influence was starting to leak into the music (or maybe not if you ask Lennon, who saw no connection with the substance and their sonic explorations), seeing as they were high as kites all the way through making the movie. Its iconic title track is as brilliant now as ever, a genuine cry for assistance from a lost Lennon. It was here of course that John really realised that a lyric could be more than a 2 minute love song, that it could carry more meaning and perhaps become a cathartic act to ease stress and worries. Musically, it's unstoppable in its infectious high energy, with those brooding backing vocals behind the aggressively brilliant lead voice. The acoustic guitars clang away, the drums clatter and Harrison's sturdy electric guitar enhances it all.

By 1965, a couple of years into Beatlemania, John was already feeling the strain. He was fed up with being the centre of the world and was finding life in the spotlight challenging. "The whole Beatle thing was just beyond comprehension," he said. "When Help! came out, I was actually crying out for help. Most people think it's just a fast rock 'n roll song. I didn't realise it at the time; I just wrote the song because I was commissioned to write it for the movie. But later, I knew I really was crying out for help. Anyway, I was fat and depressed and I was crying out for help."

On the other end, Paul gives us solid pop tracks like The Night Before and Another Girl, both your standard love songs, but

musically exciting none the less. "It's a bit much to call them fillers because I think they were a bit more than that, and each one of them made it past the Beatles test. We all had to like it," Paul later said.

John also penned one of his finest songs of the era, You've Got to Hide Your Love Away, a folky ballad sung with great feeling. The musical accompaniment is subtle; Ringo on tambourine while the acoustic guitars jangle, with a lovely little flute solo at the end. Seeing as he had a more professional attitude towards song writing, clearly still seeing it as product and his "job" so to speak, he would express his more characteristic inner thoughts into his hilarious books of nonsense poetry, both A Spaniard in the Works and In His Own Write. Here though, But John took the big step towards putting his own emotions into a song in a more genuine way, rather than a "phony" pop manner, and the result is genuinely effective. Of course, Lennon would later put even more of his own personality into the lyrics, often to a devastating effect.

"That's me in my Dylan period again," he later summarised, "I am like a chameleon... influenced by whatever is going on. If Elvis can do it, I can do it. If the Everly Brothers can do it, me and Paul can. Same with Dylan." In another interview, he explained himself further. "It's one of those that you sing a bit sadly to yourself, 'Here I stand, head in hand...' I'd started thinking about my own emotions. Instead of projecting myself into a situation, I would try to express what I felt about myself, which I'd done in my books."

Although it's been suggested by some to have been about Brian Epstein's homosexuality, this seems unlikely and no one closely connected to the band has ever claimed this. Some say it was about

one of John's extra marital affairs and it has to be said that this is much more likely. Either way, the song is one of his finest.

Harrison's I Need You is a good solid addition to the record, offering a different view point and indeed his own unique voice. Harrison's vocals were really starting to improve by 1965, his voice being instantly recognisable in its more drawly style. Lennon returns to the forefront with his brilliant You're Gonna Lose That Girl, a driven tale of love and declaration with a confident lead vocal by John. Whenever I hear the song I think of the scene in the film where they are drilling through the floor under Ringo's drum kit. The band play sturdily and there's a nice bendy Harrison solo in there too.

Help! also boasted the band's heaviest track yet, Ticket to Ride, with its tom toms and booming McCartney bass. Although The Kinks and indeed The Troggs were much heavier, this was chugging stuff for The Beatles. Boasting a fine chorus and clouded, suggestive lyrics, the most interesting aspect of the song for me is the ending where it all speeds up and becomes a bit frantic. Though the guitars and vocals are excellent, Ringo is the star of this one, his massive thudding toms marking the song out from the rest, not to mention his spot on fills and knack of upping the energy of a track.

With the first side of the album given over to the film's soundtrack, the second side has some of the more unusual and interesting material of all. Ringo gets a lead vocal on Act Naturally, written by Johnny Russell and Voni Morrison, and gives a typically charming performance. John's It's Only Love is simply beautiful, with some interesting guitar work by Harrison and deep acoustic strumming. I also like the way John rolls the 'R' on the 'bright' line. You Like Me Too Much, with its wonderful piano introduction, is a breezy, fast

paced tale of love from Harrison. Although a little corny, it has a sweet feel to it and the peculiar lyrics always brings a smile to my face.

Possibly the weakest moment on the album is Tell Me What You See, which even Paul later said wasn't very memorable. Still it's a nice enough addition, and is well recorded, despite some strangely flat sounding vocals at points. Again though, for a band worked to death, these little bits of filler came in handy, as Paul later explained. "I seem to remember it as mine. I would claim it as a 60-40 but it might have been totally me. Not awfully memorable. Not one of the better songs but they did a job, they were very handy for albums or b-sides."

This minor glitch aside, Paul does provide one of the most interesting moments on the album, the startling I've Just Seen A Face. The opening complex acoustic/electric plucking interplay is stunning, leading us into the speedy shuffle groove driven along by Ringo and a superb Paul vocal above the frantic acoustic guitars, which strum together with chaotic restlessness. "A strange up tempo thing," Paul once called it and you have to agree with him there. A most curious, yet lovely song.

It leads into one of McCartney's defining songs, the immortal Yesterday, a song which it isn't daft to say changed the face of popular music. "It fell out of bed. I had a piano by my bedside and I... must have dreamed it," Paul said of the song, "because I tumbled out of bed and put my hands on the piano keys and I had a tune in my head. It was just all there, a complete thing. I couldn't believe it. It came too easy. In fact, I didn't believe I'd written it." Seeing as Paul was the only Beatle on the track, accompanied by a small string section arranged by George Martin, it was considered to release it as a

solo record, but the other Beatles agreed it was best to credit it to the band. Yesterday may get played a lot, but there's a reason why it's remained so popular for fifty years; it's fantastic. Perhaps Paul's most perfect and beautiful moment on record. It was definitely a step up for him, and a sign that John was not always going to be the sole leader of operations.

To end it all, there's a step backwards to the rock and roll covers of the earlier days, as Lennon closes proceedings with a lively version of Dizzy Miss Lizzy. Although originally recorded for one of their US only releases (Beatles VI), it was decided that they would stick it on the end of Help!, despite the fact it sticks out like a sore thumb. Still, at least it finishes things with high energy. So Help! is a truly remarkable album, often overlooked in regards to the band's progressive work, yet full of varying shades of mood and some of the finest songs The Beatles ever recorded. In many ways it's very similar

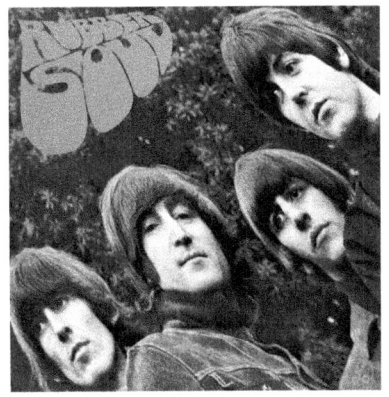

to Rubber Soul (even though Harrison claimed Rubber Soul and Revolver to be like parts 1 and 2 of the same style), marrying the traditionally uplifting Beatles sound with hints of a more introspective, troubled element.

By late 1965 the pop scene as we knew it was transforming; Dylan had gone electric, folk-rock had emerged, psychedelics were creeping in and the music that filled the charts was starting to widen in scope and meaning. As this went on, The Beatles knew they too had to progress from being pop writers of love and loss. Rubber Soul is the

first step towards the culture shifting and trend setting phase from 66 onwards, which just so happened to coincide with their decision to quite touring. By then, they had song craft down to a fine art, and their harmonies, as heard throughout Rubber Soul, were at their all time best.

Most of the record was written after the band had got back to blighty from their 1965 American tour. To show just how quick albums were recorded and released in those days, the tapes started rolling on the 12th of October, the record was done by mid November and it was released on the 3rd of December for the Christmas market. Needless to say, that is unheard of today; bands spend that much time choosing their catering menu nowadays. Back in the fast world of 1965 though, even The Beatles didn't have the luxury of spending as long as they wanted on their albums. Of course, with a year or two this would change dramatically, as the band withdrew from live appearances and spent their time perfecting their craft in the studios of EMI.

Although the LP is full of fresh ideas and approaches, it begins conventionally enough. Album opener Drive My Car, as Paul often recalls, was a Lennon and McCartney co-write which got off to a ropey start, when the pair couldn't shake off the god-awful chorus lyric of "I can buy you diamond rings." Paul said it was the only time they almost came away without a finished song. The music though is bouncy, the bass and guitars playing in unison, while Ringo gives it all a sense of excited fun with his lively drums. One of the breeziest songs of all The Beatles' catalogue, although Paul has said 'driving my car' had once been an old blues euphemism for sex

John's Norwegian Wood marks a magical moment in pop history, with the use of the sitar on a commercial Western pop record, even though Donovan will insist on telling you *he* did it first. Harrison had become interested in Indian music earlier that year, when a band had played an Eastern version of A Hard Day's Night in the restaurant scene in the film Help. Since then he had purchased a cheapish sitar and had a bash at playing it. Instinctively he picked it up during the recording of Norwegian Wood and the results were fantastic. As brilliant as the sitar melody is, the real glory is had in the middle eight section's joint harmonies between John and Paul. Long shivers go up the spine as those two iconic voices work as one to perfection.

The inspiration for the song though came from something more questionable; John's extramarital shenanigans. "Norwegian Wood is my song completely," he later admitted. "It was about an affair I was having. I was very careful and paranoid because I didn't want my wife, Cyn (the late Cynthia Lennon), to know that there really was something going on outside of the household. I'd always had some kind of affairs going on, so I was trying to be sophisticated in writing about an affair... but in such a smoke-screen way that you couldn't tell. But I can't remember any specific woman it had to do with." Despite it highlighting Lennon's less savoury and far from admirable side, it's a stonker of a song.

Nowhere Man is another sublime yet troublingly neurotic Lennon monologue, and at this point it's clear he is dominating the record. moving things up a gear or two. The lyrics are saddening, yet the bittersweet melody and Beatle harmonies lift it upwards towards something beautiful. The song was born out of a similar experience Paul had with Yesterday, in as much that it all seemed to come from

elsewhere. "I'd spent five hours that morning trying to write a song that was meaningful and good," John later said, "and I finally gave up and lay down. Then Nowhere Man came, words and music... the whole damn thing, as I lay down. So letting it go is what the whole game is. You put your finger on it, it slips away, right? You know, you turn the lights on and the cockroaches run away. You can never grasp them."

The guitars sound particularly brilliant on this track, lacking in heavy bass and actually piercing the ears a little, in the most positive way of course. In fact, it was a trebly effect the band were deliberately going for. Ringo drums with precision, one of his classic time keeping sturdy beats ("I am the fucking click track," were Ringo's words when pointing out Jeff Lynne's fondness for using the recording device) and the whole track has a haunting feel about it. Perhaps that's down to the fact that John felt like he really was the nowhere man. In his Beatles book, Hunter Davies got a telling and very sad quote from Lennon about his life at that point.

"I can get up and start doing nothing straight away. I just sit on the step and look into space and think until it's time to go to bed. If I am on my own for three days, doing nothing, I almost leave myself completely. I'm just not here. Cyn doesn't realise it. I'm up there watching myself, or I'm at the back of my head. I can see my hands and realise they're moving, but it's a robot who's doing it." Clearly, Lennon was a man on auto pilot, yet to meet the woman who became his mother, partner and guardian - but her arrival was still a couple of years away.

The Word, with the three guitar wielding Beatles on joint vocals again, is a prime example of how close they could be musically when

they really wanted to be. It's at this point and perhaps on Revolver too that the band sound as tight knit as they ever did, the instruments gelling together with ease and crystal clear voices overlapping one another to great effect. Unlike on the albums that followed it, they weren't relying on that much studio trickery and as we know, on later records they were often adding bits alone and working on tracks in separate studios to one another. As a result they lost their once solid togetherness as a band. (This is evident on the Let it Be sessions, were they do sound quite rusty.) Here though, they show off their trademark musical simpatico.

Michelle is one of the band's most popular and covered numbers, a McCartney master class which started as a jokey French party piece he would bring out, before becoming the immortal love ballad it is now. What Goes On is the album's obligatory Ringo moment, a nice jolly distraction from the weirder and more troubling elements making their way in.

The remarkable Girl was something of a fantasy song for John, all about the elusive girl that hadn't yet arrived to save him. "It was Yoko," he later commented. There's a real pain in there though, a longing, a lusting even for this imaginary person yet to show themselves. "There is no such thing as the girl," Lennon said, "she was a dream." A truly wonderful song. On the other end of the spectrum is Paul's other genuine hair raising moment on Rubber Soul, his glorious I'm Looking Through You, with its claps, double tracked vocals and jangly acoustic guitars. The organ stabs, fiddly guitars and nice loose drums give the song its real intensity, while Paul's voice sounds at its best.

Possibly the highlight of the record though is one of John's signature tunes, In My Life, pop perfection if there ever was such a thing. A clearly autobiographical song, John is looking back on his life, despite the fact he was only 25 at the time, highlighting what a deep man he really was underneath the bravado and aggression. Julia Baird, John's half sister, emailed me about John's music, nailing his organic approach to art and inadvertently reflecting the autobiographical quality of this very song.

"There's not much I can tell you about John's music," she wrote. "The songs were, in John's case, the story of his life. Ironically, when asked in interview if would he ever write his autobiography, he laughed and said that would be a stupid thing to do; he couldn't understand why people did it."

The melody of In My Life is heartbreakingly beautiful and it's strengthened by some of the band's finest harmonies. John sounds pure and sincere in voice while musically it's Ringo who stands out with some interesting and carefully played drumming.

The three closing tracks are, for me, the three lesser ones on the album; namely Wait, Run For Your Life and If I Needed Someone, although the latter is the strongest. Still, they don't quite live up to the rest of the LP. Wait has a calm verse, with subtle Ringo hat work, before it all comes in full force for the chorus. The highlight of the track is Paul's wonderful middle eight part, his vocals sounding particularly strong at that point.

Reviews were good of course and sales were out of this world, but some critics seemed underwhelmed with the change in style. Melody Maker wrote, "The new Beatles album is not their best on first hearing. It probably won't achieve much acclaim... although one or

two tracks should stand out for a few months." The Record Mirror didn't think it was their best either, but did call it "a gas."

Throughout the speedy 35 minutes of Rubber Soul, the band pull together to create their first truly outstanding album, where nearly every moment seems to have been carefully considered and mapped out (even if it hadn't been). It proved to be the band's first stepping stone towards true, unparalleled musical artistry; the most accomplished music of the 20th century.

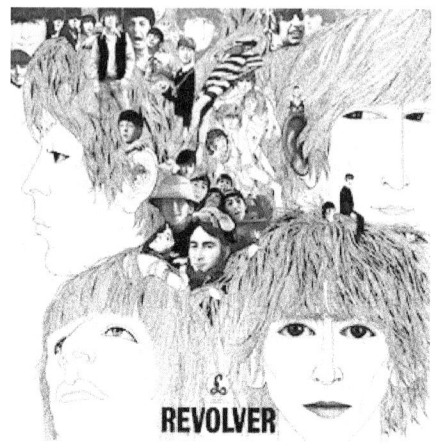

REVOLVER

"Paul was right," Melody Maker wrote of Revolver upon its release, "they'll never be able to copy this one! The Beatles have definitely broken the bounds of what we used to call pop." They weren't wrong.

The release of Revolver marked the distinct point in popular music when the rules of convention that existed between genres and accepted styles became completely expanded. Bands were no longer split into tidy categories; rock and roll didn't have to just be guitars and drums, it could encompass all manner and styles of varied instrumentation. The innovative introduction of Eastern sounds on Rubber Soul led to the groundbreaking liberation heard on Revolver. By then, the boys' curiosity had led to George Martin becoming more actively involved in their musical ideas, and his stereo mixing brought the songs right into your living room, utilising the latest tricks in recording technology. Electronic experimentation and the avant-garde came to the fore with the mind-bending weirdness of

Tomorrow Never Knows, with its tape loops and backward guitars. The song writing also entered completely new territories; the music scholars and so called intellectuals began to take not just the music of The Beatles seriously, but the whole of the pop world in general. Their lyrics were dissected and pondered the world over. After all, this was a new age; the birth of modern rock and pop as we know it.

Revolver begins conventionally enough though with a straight rocker, George Harrison's wonderful Taxman, a vicious attack on the unfair tax system of 1960s Britain. The jagged chord strikes sharpen the dagger and the band rock together with their venomous guitar licks, pumping bass and heavy drums. The way they hiss the names Mr Wilson and Mr. Heath (the Labour and Conservative leaders at the time) is pure gold. It has to be said that it's Harrison's first truly great song in The Beatles catalogue, right up there with some of John and Paul's strongest. It was from then on that fans and band mates alike began to take his song writing skills more seriously. Paul though is the one who plays the solo on Taxman, illustrating what a fine axe man he is himself. "Taxman was when I first realised that even though we had started earning money, we were actually giving most of it away in taxes," Harrison later commented, before adding "It was and still is typical."

Highlighting the band's knack for merging completely opposing sounds side by side, the follow up track is Eleanor Rigby, one of the key songs that triggered musicologists and journalists to assess the true artistic merits of The Beatles' output. Listening to it now, it's very striking and quite a dark song too, with Paul's vivid descriptions taking you right into the lives of the lonely people. The string arrangement is both haunting and beautiful, and had the song been

played in a traditional guitar format much of the power might have been lost, although the lyrics themselves do paint a thorough portrait in their own right. Precise and poignant characterisations are painted by so few words, and it has to be said that not many songwriters can achieve this with such ease.

I'm Only Sleeping is a tired out Lennon interval, almost a precursor to his later and more wound up I'm So Tired from the White Album. John loved lying in bed, just lazing around under the covers and this is his immortal tribute to the said activity. It couldn't be more different to the next track, Love You To, Harrison's second song on the album. Beginning with those dreamy, almost surreal sitar notes, the journey sets off taking us into a completely different world. More grounded is Here, There And Everywhere, a classic McCartney lullaby that even Lennon had to admit was great in an early 70s interview he gave, a time when he was supposedly at his most anti-Paul. Inspired by The Beach Boys, Paul's beautiful ballad stands up as one of his finest love songs, of which there are many of course. The album moves swiftly on to Yellow Submarine, now one of the band's most universally known tracks, bringing Ringo to the fore on vocals. Purposely written as a children's song, it takes us on a magical adventure under the sea, away from the struggles and stresses of adult life. Although often belittled and laughed at these days, it's a lovely song and Ringo's endearing voice carries it with authenticity. No other band could have pulled off a song of this nature so well.

She Said She Said was always a favourite of mine in the whole Beatles catalogue. A snarling Lennon lyric over a whirling backbeat, the song also features some odd time signature changes, which no one at the time was really attempting. It was all inspired by an

encounter with the actor Peter Fonda, who was sat with the band at a Hollywood get together. He irritated John by repeating that he knew what it was like to be dead. Of course, these were stoned ramblings and seeing as Lennon was tripping himself on LSD, he didn't want to hear anything too heavy. Knowing he inspired a Beatles classic, I'm not entirely sure how Fonda might feel about this song.

At his most honest and biting, John spoke of the track in an interview shortly before he was killed. "That's mine. It's an interesting track. The guitars are great on it. That was written after an acid trip in L.A. during a break in the Beatles tour where we were having fun with the Byrds and lots of girls. Peter Fonda came in when we were on acid and he kept coming up to me and sitting next to me and whispering, 'I know what it's like to be dead.' He was describing an acid trip he'd been on. We didn't 'want' to hear about that. We were on an acid trip and the sun was shining and the girls were dancing, and the whole thing was beautiful and Sixties, and this guy - who I really didn't know - he hadn't made Easy Rider or anything, kept coming over, wearing shades, saying, 'I know what it's like to be dead,' and we kept leaving him because he was so boring!"

The music itself is stunning, jagged and angular; the guitaring is wonderful and Ringo's drum performance is among his finest. For me it's an impeccable number.

And so the genius of The Beatles' creativity continues with a complete contrast. Opening side 2 is Paul's chirpy Good Day Sunshine, an uplifting ode to life and the joys of spring. It's quite a bare arrangement, mostly bass, piano and drums, but a lovely slice of happiness after the bite of She Said She Said. Lennon's And Your Bird Can Sing has a pointy double guitar melody played by both Paul and

George, and lyrics that have been open to much interpretation. Some say it was a stab at Mick Jagger and Marianne Faithful (the latter is convinced), but John denied any of this. A lot of the time he claimed to be just putting words together for no apparent reason, just to fit the music, although I am sure he meant something with this one. Musically, it's more similar to something off Rubber Soul, but a nice breezy, speedy detour.

For No One is another personal favourite. Paul's pure lyrics really do sum up a dying love; the heavy sadness and regret of a fading relationship. The trumpet solo is especially beautiful, but the whole track itself has a gorgeous sound to it, with descending piano and bass working together with gentle percussion.

Doctor Robert is my least favourite song on Revolver, but within an album this strong that doesn't mean I don't like it. It sounds more like filler than anything else on the record, and as McCartney once stated it was meant as more of a joke, with Lennon referencing an individual who solved all life's problems with a pill or drug. Yet another dimension of Revolver is the Motown groove of Got to Get You Into My life, McCartney's upbeat brass dominated love song. The fact that the object of his infatuation is pot... well that's beside the point. To the innocent listener, Paul was singing to a girl.

In what feels like such little time, the album comes to a close with the monstrous Tomorrow Never Knows, a spaced out pre-cursor to the psychedelic movement. Inspired by the work of Timothy Leary (author of The Psychedelic Experience) and also the original Tibetan Book of the Dead, John asks us to relax and look inside ourselves, although the obvious drug references are what most people will take away from this one. Musically, it sounds like the future, even now. In

fact it sounds like something created elsewhere, music of the afterlife, of space and infinity. The fact it is little under three minutes long and nearly 50 years old seems almost irrelevant. It spins around your head, knocking around with Ringo's solid impenetrable back beat, as backwards guitars and loops unreel the tape of the mind. It was a heavily produced song to say the least, but it heralded the arrival of a whole new way of recording music. Song structure is clearly out of the window, traditional melody non existent. This is pure ambience. Harrison himself noted that John probably didn't even know what he was really saying and failed to understand the real aspects of meditation. But all that really doesn't matter. It's an incredible song, and a blistering finale to one of the most varied and colourful albums ever recorded.

Revolver has all the hallmarks of a classic Beatles album and all the things we loved about them are present in equal digestible measures. There's not too much studio trickery on display, only a touch of psychedelia, very few throw away lyrics and enough tight band dynamics to get the balance just right. Truly a gift of a record.

58

The Beatles

STRAWBERRY FIELDS FOREVER AND PENNY LANE

"I love Strawberry Fields, it's only a scrap of the original, but I still so love the song and remember Brian Epstein playing it to me when I first went to see him to discuss the book."
- Hunter Davies, writer of The Beatles official biography, to me.

Although the release of Revolver was certainly a distinct turning point for the band, the release of the double A side Strawberry Fields Forever and Penny Lane can be seen as a more suitable and definitive divider between the first Beatle phase and the second. Utterly psychedelic in the truest, most natural and least contrived way possible, John's haunting and surreal return to childhood is among the greatest songs ever released. Based on his memories of the

Children's Salvation Army Home, and playing around the grounds there as a boy in Liverpool, we can all channel our own personal thoughts into John's dreamy otherworld of yesteryear. Images of our long gone early years come floating back to the forefront of the mind, carried on the breeze of George Martin's exquisite production, The Beatles' freakish fairground backing and John's shiver inducing vocals.

Revolver had moved The Beatles from pop stars to serious artists in one record, yet the leap they made with Strawberry Fields Forever and its equally fascinating counterpart Penny Lane, written by Paul, cannot be understated. In 1967, the sounds that Martin and the band managed to conjure up must have sounded like alien craft landing on earth, especially to those who had loved the four zany mop tops of the Hard Day's Night era. Visiting the very destination upon which John based his Lewis Carroll-esque monologue, you get the sense of returning to a place you feel like you've been to countless times yourself. It doesn't matter that John played in the garden behind it and visited the summer garden parties there; it's what the place itself represents that causes generation upon generation to relate to it. Strawberry Fields sums up those long hot summers we all had as children, those endless days of adventure, exploration and discovery. It was back when the world didn't seem so scary and full of badness, when the biggest responsibility of the day was to make sure you got home in time for your tea.

John wrote the lyrics, or the start of them, in Spain while filming his role in Richard Lester's How I Won the War. Lester had obviously enjoyed directing The Beatles in Help! and A Hard Day's Night, and saw that Lennon had screen presence. Asked to play a part in it, and

with little else to do now that touring for the band had ceased, John happily accepted the role. John made the lyrics to the song more hidden and clouded, firstly by mixing up the English sentence structure to a fragmented conversational format and then adding in some surreal word play. Old acoustic demos prove it was always a good song, being both melodically and lyrically rich in vivid detail, yet almost childishly simple at the same time.

The various attempts to record it in a conventional full band set up show how the song moved on and progressed. With McCartney's weird mellotron introduction, the song enters another realm all together and thanks to George Martin's technique of splicing two versions of the song together, thus pitching John's voice differently in one section, the resulting single was something of a genuinely mind bending oddity. It's a work of genius and every time it comes on, it never loses any of its enigma.

Musically there is so much to take in, the odd mellotron not withstanding. One overlooked aspect of the song's power lies in Ringo's percussion. At times there is an almost tribal feel to it, and on the outro it sounds like a thousand drummers marching along in unison. Much of the song's magic is down to the arrangement and the production techniques yes, but it doesn't take away any of the strength of the lyric and the unforgettable melody.

In 1980, John told Playboy of the song's inspiration and a little of his past. "Strawberry Fields is a real place," he said. "After I stopped living at Penny Lane, I moved in with my auntie who lived in the suburbs in a nice semidetached place with a small garden and doctors and lawyers and that ilk living around... not the poor slummy kind of image that was projected in all the Beatles stories. In the class

system, it was about half a class higher than Paul, George and Ringo, who lived in government-subsidized housing. We owned our house and had a garden. They didn't have anything like that. Near that home was Strawberry Fields, a house near a boys' reformatory where I used to go to garden parties as a kid with my friends Nigel and Pete. We would go there and hang out and sell lemonade bottles for a penny. We always had fun at Strawberry Fields. So that's where I got the name. But I used it as an image. Strawberry Fields Forever."

For his part, keeping up with the classic McCartney and Lennon "friendly" rivalry, Paul penned his own nostalgic portrait of childhood in Liverpool. Penny Lane is more straight forward, and certainly "clean" sounding as Paul later said. The band plays tightly, and Paul's lyrics are more playfully surreal, lightly turning phrases and images on their heads. Penny Lane was direct, down to earth and conventionally melodic.

In my view this double A side was the best single The Beatles ever released, and the fact it was kept off the top spot by Engelbert Humperdinck's Please Release Me is frankly hilarious. John and Paul though said they had nothing against Humperdinck and didn't mind him hogging the top of the charts as he was obviously doing something completely different to them. Ringo said it was actually a relief that they didn't have the pressure of instantly going to number one for once. Time has told though which of the songs has had the most lasting power. Today, that one release marks a turning point in popular music, bringing in psychedelia and leading to what some people see as The Beatles' own crowning masterpiece.

SGT. PEPPER'S LONELY HEART'S CLUB BAND (1967)

I always loved that moment in The Beatles Anthology documentary when Paul suddenly appears rather immodest - after coyly admitting time after time that The Beatles were just a good little rock and roll band - and out comes a rightfully bitchy attitude towards the press who were, prior to the release of Sgt Pepper, suspecting The Beatles of drying up. He says to have got a real kick out of the release of Pepper, with two fingers proudly held up at the doubters, as they blew them away with the mind expanding, culture changing masterpiece. "Oh yeah, drying up..." he smugly adds. The press are always ever so keen to kick someone down, but there was no doubting that with their new album The Beatles had created a

modern classic, an album which many still claim to be the greatest of all time. You may not be a fan of them, but no one can deny the musical and cultural importance of Sgt Pepper's Lonely Hearts Club Band.

Apparently a name first thought up by the band's friend and roadie Neil Aspinall, Pepper began to take shape when Paul had the idea of making an album under the name of a made up band. With touring still out of their plans for the near future, it was time to use the studio as an instrument and to expand everyone's expectations of both The Beatles as a band and what was actually humanly possible to achieve on record. Although they call it a concept album, the concept itself falls by the wayside quite early on, and only comes back for the second to last track. The Pepper band do open proceedings, but they make way for Billy Shears (Ringo) by the second track and only make themselves apparent on the reprise of the title song. But who cares? This is still an amazing album, one that never loses its magic after countless listens.

Going against his clichéd public image as a thumb raising Mr Positivity, Paul later vented his annoyance at the band's media perception in that era. "We were fed up with being Beatles," he fumed. "We really hated that fucking four little mop-top boys approach. We were not boys, we were men. It was all gone, all that boy shit, all that screaming, we didn't want anymore, plus, we'd now got turned on to pot and thought of ourselves as artists rather than just performers... then suddenly on the plane I got this idea. I thought, Let's not be ourselves. Let's develop alter egos so we're not having to project an image which we know. It would be much more free.'" If Pepper was a chance for the boys to escape the insanity of Beatlemania, the irony is

in the fact that reaction to its release was more frenzied than it was for any of their previous albums.

The opening title track is instantly recognisable from that first thundering piece of guitar, bringing us into the fantastical world of the Heart's Club Band. McCartney's voice is at its absolute peak here, screeching the vocals out in pure rock star delight, while the whole band stomp along heavily, accompanied by the brass interlude and approving cheers of the invisible crowd. When it leads into the wonderful With A Little Help From My Friends, the album progresses into traditional album format with unrelated songs, regardless of what they say about concepts. Again, Ringo's voice is excellent (he's always been an underrated singer in my book), perfectly conveying the simple, child-like melody. Its appeal hasn't dimmed all these years on and although these songs are so well known that some people are sick of them, you cannot deny the magic that was put on to record.

Lucy in the Sky With Diamonds is phenomenal still to this day, with Lennon's wonderful fantastical lyrics conjuring up some of the most unusual and spell binding images possible. Although we all know of the supposed drug references in the song, it was actually inspired by a drawing John's son Julian did, even though some still claim it's a direct LSD song. To the John Lennon of 1980 though, a man who had gone through his difficult personal phase and come out the other end as a seemingly more stable family man, the song was certainly not about drugs. In fact, retrospectively he could see a figure clouded within the lyrics, someone he hadn't even met when the song was originally written. "There was the image of the female who would someday come save me," John said, "a 'girl with

kaleidoscope eyes' who would come out of the sky. It turned out to be Yoko, though I hadn't met Yoko yet. So maybe it should be 'Yoko in the Sky with Diamonds.' It was purely unconscious that it came out to be LSD. Until somebody pointed it out, I never even thought it, I mean, who would ever bother to look at initials of a title? It's NOT an acid song. The imagery was Alice in the boat and also the image of this female who would come and save me - this secret love that was going to come one day. So it turned out to be Yoko... and I hadn't met Yoko then. But she was my imaginary girl that we all have."

Interpretations and nit picking aside, the song's musicality is simple yet direct. Indeed, there are no mad guitar solos or sonic over indulgences here. The Beatles play as a tight unit, with keyboards, bass, drums and guitar, no frills save for Lennon's wonderful, double tracked vocal. With the word psychedelic today meaning so many different things, whether it be freaky ten minute guitar solos or mind bending Hawkwind space rock, it's easy to lose sight of its original meaning. It was a term the media coined, again in a way to summarise a growing sonic style that was creeping into the former Beat bands' musical approach, moving on from the standard R and B material they had started out playing. While it's arguable that The Beatles invented psychedelia in the first place, they certainly toyed with it for a brief period and cut what I feel to be the most tasteful and straight to the point examples of that most muddled and often self indulgent genre.

Getting Better is interesting musically, but it stands out in the record for one main reason. It's probably the best and tidiest example of the way Lennon and McCartney worked on a song together and combined their very opposing styles and views for a superb result.

Paul's optimism with his insistence that it's getting better is hardened by John's witty and cynical "it couldn't get much worse." Although the ongoing cliché of Paul being upbeat and John being the harder man is getting very tired these days, it's hard to resist pointing out the clarity of that fact in this particular song. It's like both the media and the public's perception of the two men summed up plain and simple in a single track. It's also notable due to the fact that Lennon went up on the roof during its recording to get some air, as he was feeling a bit funny. Perhaps the reason he felt so off it was due to the fact that he was unknowingly tripping on LSD. Unbeknownst to the truth of his altered state, it was George Martin who kindly took him to the roof to sort him out. A dazed Lennon was staring at the stars, proclaiming how amazing they were. Martin added dryly, "they were just stars to me, but to him they must have looked extra special."

Lennon gives us Being for the Benefit of Mr Kite next, a song almost completely lifted from a poster he came across for an old circus show. "It's all just from that poster. The song is pure, like a painting. A pure watercolour," said John in a later interview. The whole surreal fairground feel of the track, with its twirling organ, double tracked dreamy vocals and sound effects, makes it one of the band's most openly psychedelic songs. It can be appreciated on many levels though, especially lyrically, where it highlights Lennon's sheer knack of making a decent song out of anything. Still, the song is made what it is by the contributions of George Martin, whose wizardry lifts it from a novelty idea to a stand out classic. He applied similar trickery to Strawberry Fields Forever too, the single released before Pepper. (Just think, if they had decided to include Strawberry

Fields and Penny Lane on the album rather as stand alone singles, how much more amazing Sgt. Pepper would have turned out.)

Harrison's sole track on Pepper is With You Without You, another Indian styled number, although in my view a weaker one than Love You To. Harrison's playing throughout is fantastic, and the sounds are dreamy, but for me the song itself slows the album down with its lack of structure and hook. Not taking away its brilliance, it's just the least enjoyable moment for me. When I'm Sixty Four couldn't be more different though, Paul's very own old style music hall number (he wrote it to please his dad, who loved it and played it constantly at home). Although Lennon called this side of McCartney's writing "granny shit" and often expressed his dislike for it, you cannot say the song isn't enjoyable. In my view it's charming and very witty, while the musical arrangement is perfect (hats off to George Martin for that). As English as fish and chips, it's a celebration of the England of old and should be valued, not dismissed. Corny yes, but definitely classy too.

Lovely Rita is another nice McCartney number, although some call it the one filler on the album. Lennon himself called it the kind of song Paul made up "like a novelist" before adding that he himself wouldn't be interested in writing such a song. Yet despite Lennon's dismissive attitude towards it, it's a wonderful little track, full of interesting images, sounds and musical ideas. Its chirpiness clashes hard with Lennon's druggy, hazy Good Morning Good Morning, a song inspired by a Kellogg's Corn Flakes advert John saw on TV. It's a statement on every day life in suburbia; a great little song, even though its author later dismissed it as garbage.

It is then that Pepper and the band return to the proceedings for the reprise, twice as fast and more rocking than at the start of the LP, leading us into the album's strongest song, the epic A Day in the Life. Pulling together a scrap of song that McCartney had lying around and Lennon's haunting verses he lifted from news stories in the paper, A Day in the Life is perhaps the greatest pop song ever recorded. There's an indescribable power and magic to it all, right from the moment John opens his mouth to deliver the immortal opening lines. The whole song is perfectly crafted, a mini masterpiece within a masterpiece of an album. It's the sound of England being on top of the world. The brass crescendo, the resonance of the final piano chord, the wonderful words; it's all so fantastic. There can never be another song to match it.

"A Day in the Life - that was something," Lennon said in 1968. "I dug it. It was a good piece of work between Paul and me. I had the 'I read the news today' bit, and it turned Paul on. Now and then we really turn each other on with a bit of song, and he just said 'yeah' - bang bang, like that. It just sort of happened beautifully, and we arranged it and rehearsed it, which we don't often do, the afternoon before. So we all knew what we were playing, we all got into it. It was a real groove, the whole scene on that one. Paul sang half of it and I sang half. I needed a middle-eight for it, but Paul already had one there."

Paul has always praised the song in interviews and credits most of it to John. "That was mainly John's, I think," he said. "I remember being very conscious of the words 'I'd love to turn you on' and thinking, Well, that's about as risqué as we dare get at this point. Well, the BBC banned it. It said, 'Now they know how many holes it takes to fill the

Albert Hall' or something. But I mean that there was nothing vaguely rude or naughty in any of that. 'I'd love to turn you on' was the rudest line in the whole thing. But that was one of John's very good ones."

Sgt Pepper was a cultural phenomenon and of course a massive seller, back in the days when an album could sell a quarter of a million copies in its first week of release in the UK alone. It's still ranked as the best album ever made in a lot of lists and polls, and although people get sick of hearing about it, the fact remains that it's an extraordinary piece of work. Harrison found the album boring and Ringo said he liked it, but as he had so little to do once his drum parts were done, he too got bored ("I learned how to play chess on it," he says in Anthology). Lennon later dismissed it and seemed to think it was over rated, being a product of its time which summed up a time and mood. Pepper has been criticised as being over reliant on studio tricks and has even been called soulless by its harshest critics. I personally find it to be a sublime example of extraordinary young minds being allowed to run completely free, something we never see in the music business these days. It really is a towering achievement.

THE MAGICAL MYSTERY TOUR

Cast yourself back to 1967. Now that touring was long over and with activity floundering after the tragic death of Brian Epstein, McCartney was becoming the most proactive of his band mates, always trying to get them off their back sides and working on something new. After all, Sgt Pepper had been born out of Paul's wildly creative mind and now, with two films behind them (the seminal Hard Day's Night and less influential but equally entertaining Help!), it was time for another feature length Beatles adventure. Only this one was to be directed by Paul and have no real plot. Originally conceived with simplicity and looseness by McCartney - who drew a circle and started writing rough drafts of scenes around the shape - the ideas within the film grew more and more off beat as it went along. Inspired by both the author Ken Kessey's psychedelic bus and the Northern tradition of seaside road

trips fuelled by bawdy songs and booze, Paul came up with the idea of having The Beatles go on a mystery tour, with a tour guide and all kinds of freaky, unusual people on board.

The film itself, in style and editing, owes more to European art cinema than anything else, and some sections are certainly reminiscent of The Goons. The fact that the truly potty Bonzo Dog Doo Dah Band appear, and perform their own song Death Cab For Cutie in the middle of the film, adds an extra dose of British surrealism to the whole experience. The band were led on vocals by the legendary Viv Stanshall, a naturally eccentric character to say the least. Neil Innes was songwriter and multi instrumentalist. Roger Ruskin Spear of the Bonzos told me about how the band first got involved with the movie: "They (The Beatles) had been looking for a visual type band for the film and had spotted the New Vaudeville Band at the top of the 'Hit Parade' as it was then. They were to be booked, but Paul's brother, Mike McGear from the Scaffold, put Macca on to us as the 'Originals' and far better. We had done many shows sharing the bill with the Scaffold."

The scene with the Bonzos playing their song also involves a stripper, as The Beatles and the other guests come in to enjoy the show. "It was shot at Raymond's Revue Bar in Soho," Roger says, "and was like any other shoot really, although it was more like a school outing with the schoolboys playing with their newly acquired movie cameras; the actual film was, of course, shot professionally by a film crew. Personally I didn't connect with any of them - not my type really; they seemed to be mainly up their own arses, although very open and polite and good natured. But very aware they were something special. Viv was chuffed when George wanted to wear

Viv's hat for the shoot. You can see George wearing it during the number as they were in the 'audience'. They didn't have much to share as they were just revelling in all that instant fame supplies when delivered to lads so young. We came down from a gig up north (one of the many weeks we spent in the cabaret circuit) just to do the shoot and I brought with me at great effort the robots, but they weren't considered any good for the scene, so the fab four snapped them with their personal cinecams 'for their own use.' The footage may be lying somewhere - but I doubt it."

George Harrison once famously commented that he felt when The Beatles parted ways in 1969/70, some of that spirit went into the comedy group Monty Python. Watching Magical Mystery Tour, it's amazing to think that Python, now recognised as the originators of alternative surreal comedy on TV, didn't even exist when this film was made, although they *were* active separately in other TV shows. Some of the scenes really do go parallel with the classic Flying Circus moments; indeed, there's a distinct Upper Class Twit of the Year feel to much of the manic racing and chasing sequences in Mystery Tour. So it seems rather fitting that Python planned to play Mystery Tour before the Holy Grail movie in cinemas upon its release in 1975. After all, Lennon himself once said he'd have preferred to have been a member of Monty Python than a Beatle.

Although the Magical Mystery Tour film and album divides fans, it's right up there with my favourite Beatles material. Originally released in the UK as a double EP with a lavish booklet, the modern CD and vinyl release of the album also features tracks and singles from around the period, such as All You Need Is Love and Strawberry Fields Forever, for me comprising many of the strongest

songs they ever recorded. Magical Mystery Tour is the one I seem to return to most often. But why? Well, it must be the sheer sense of limitless freedom, the lack of conservatism, the absence of any fear or attempts at commerciality. More simply, there are some damn fine songs on it. It's easy to call it a "poor man's Pepper," as indeed many reviewers have, but there is so much more to it than mere derivative psychedelic dreaminess.

Hunter Davies captured the first part of the recording of the album's title track in his biography of The Beatles, where all the group and their associates were gathered in the studio, banging and clattering whatever was at hand. Paul was asking Mal Evans, their roadie and helper, to write down the words on paper as Paul came up with them. Lyric wise it's not up to much, but musically it's fantastic, and like the title track of Sgt Pepper, it opens proceedings with a bang.

The Fool on the Hill is a classic piece of Paul, a wonderfully melancholic song we can all relate to; after all, how many have us have observed that slightly odd local loner living out his eccentric day to day life? When listening to the flutes and whirling arrangement, one can't help but picture that prattish grin Paul wears in the video for the track (that segment of the movie was actually filmed in France, with Paul and "a few mates" taking cameras over there for a couple of days). It's a beautiful song in itself, with or without he filmed segment.

Although Flying is a nice instrumental, it was clearly something they had lying around and used to fill some space. Still, I think it's a wonderful piece of 12 bar simplicity that transports you away to elsewhere, especially when hearing it alongside the trippy landscape

visuals in the movie with those hypnotic changing colours (something lost on TV viewers at the time, seeing as the BBC played it in black and white). "Flying was an instrumental that we needed for Magical Mystery Tour," Paul later said. "So in the studio one night I suggested to the guys that we made something up. I said, 'We can keep it very, very simple, we can make it a 12-bar blues. We need a little bit of a theme and a little bit of a backing.' I wrote the melody, otherwise it's just a 12-bar backing thing. It's played on the mellotron, on a trombone setting. It's credited to all four Beatles, which is how you would credit a non-song."

The crowning moment for me is Lennon's astonishing I Am the Walrus, a mind boggling orgy of surreal poetry and disturbing sounds. The lyrics were inspired by Lennon's bafflement and sheer amusement at the fact that people were really starting to dissect his lyrics, most perversely of these being the teachers of his old school, Quarry Bank High School. He filled his song with more Lewis Carroll images, even lifting the title from Carroll's classic Walrus and the Carpenter. The group rock and stomp along solidly behind George Martin's nightmarish string arrangement and the vocal melody, inspired by a police car siren, is hypnotically brilliant. Together it makes for an extraordinarily odd and unique monster. For his part, Paul adds a booming and imaginative bass line.

"The first line was written on one acid trip one weekend," John recalled of his mighty masterpiece. "The second line was written on the next acid trip the next weekend, and it was filled in after I met Yoko. Part of it was putting down Hare Krishna. All these people were going on about Hare Krishna, Allen Ginsberg in particular. The reference to 'Element'ry penguin' is the elementary, naive attitude of

going around chanting, 'Hare Krishna,' or putting all your faith in any one idol. I was writing obscurely, a la Dylan, in those days. It's from 'The Walrus and the Carpenter.' 'Alice in Wonderland.' To me, it was a beautiful poem. It never dawned on me that Lewis Carroll was commenting on the capitalist and social system. I never went into that bit about what he really meant, like people are doing with the Beatles' work. Later, I went back and looked at it and realized that the walrus was the bad guy in the story and the carpenter was the good guy. I thought, Oh, shit, I picked the wrong guy. I should have said, 'I am the carpenter.' But that wouldn't have been the same, would it? (Singing) 'I am the carpenter...'"

The CD issue of the album strengthens an already decent set of tracks, by putting Hello Goodbye, Strawberry Fields Forever, Penny Lane and All You Need is Love in the mix. Had they maybe released this as a long player in the first place, I believe the public's mythically hostile reaction to Magical Mystery Tour would have been much different. Anyway, more to the point. my dad loved the EP and the film when it came out in 67 and he said everyone he knew liked it too, even his parents!

THE BEATLES' WHITE ALBUM

It's funny to think that for a band so known for their iconic imagery and innovative album cover artwork, that one of their highest selling albums comes in a totally plain sleeve, save for the band's name embossed distantly on the purely white cover. It was an unusual idea for a sleeve to say the least, but seeing as The Beatles would sell boatloads of records no matter what the cover was, it didn't seem to matter. On the other hand, emotions are completely stripped bare on what is now known as the White Album and the simplicity of the cover is like a statement to the world; this is who we are, no frills, no bullshit. They may also have been pointing out the ludicrous nature of selling a record, posing for the cover and dressing it up with a load of fanciness, when they knew full well they could sell millions of records if it came in a brown paper bag.

There's the clichéd theory that maybe the band should have ditched the double album idea all together and released a stronger single LP, a view that George Martin has always stuck by. But without the odd little interludes and experimental weirdness, would the White Album be the masterpiece it truly is? With four sides, as if there was one spare for each band member (or each personality trait at least), anything and everything seemed like fair game. Songs had been stockpiled in India while the band had been meditating with the Maharishi, and the acoustic flavour throughout is what separates it from other Beatles records. Inner demons were faced after the death of manager and friend Brian Epstein, dark thoughts were brought to the surface and social revolutions were pondered; the White Album was The Beatles at their most honest, direct and, it has to be said, weirdly playful.

Things begin in a fairly straight forward manner though, musically at least, with Back in the USSR. Paul is in his rock and roll element in a track inspired by The Beach Boys in the harmonies and good old Chuck Berry in the chord structure. Things soon get deeper though. Dear Prudence is a track John wrote while in Rishikesh with the band (plus various friends such as Donovan and Mia Farrow) and the Maharishi. It was aimed at Prudence Farrow, sister of Mia, who had shut herself away from the others while meditating. This is John's call for her to come out to play. "I think it did actually work," Paul later commented. There's some really cool guitar work on this track and McCartney steps in for Ringo on drums and does a fine job. When it leads into the sharp and venomous Glass Onion, the album makes its first forays into its gloomier tunnels of surrealism. Lennon is having a go at the experts again, putting in references to I Am the

Walrus and the Fool on the Hill, taking pot shots at those who spent their time analysing every single word that John wrote. The baroque string section arrangement is what makes the song something special though, for the constant references to past songs does wear a little thin after a while. Still, there is a great menace to his double tracked vocals. John, now side by side with Yoko at all times, found it easier to explore his inner thoughts and get them out on to record without feeling the need to dress them up as poppy frilliness. For the first time, he was totally naked.

The truly wacky Continuing Story of Bungalow Bill is, in some ways, one of my favourite tracks on the whole album. Telling the tale of one of the Maharishi's wealthy pupils in India (Richard E Cooke III) going out to hunt and kill a tiger, then coming back in the evening to meditate, it's one of John's most savage lyrics. Clearly Lennon couldn't help but point out the irony and sickening hypocrisy of a man going out to kill a helpless beast, then coming back to look for inner peace. Musically it's ragged and rough round the edges, all clattering percussion and jangling acoustics. It's a great pastiche of that All American camp fire sing along.

"At the Maharishi's meditation camp, there was a guy who took a short break to go away and shoot a few poor tigers and then came back to commune with God," Lennon explained. "There used to be a character called Jungle Jim and I combined him with Buffalo Bill. It's a sort of teenage social-comment song. It's a bit of a joke."

As you might expect, Animal Rights spokesman Paul loves the song. "I remember John singing Bungalow Bill in Rishikesh," he said. "This is another of his great songs and it's one of my favourites to this day because it stands for a lot of what I stand for now. 'Did you really

have to shoot that tiger' is its message. 'Aren't you a big guy? Aren't you a brave man?' I think John put it very well."

Another Lennon stand out comes in the dark and compelling complexities of Happiness is a Warm Gun. The title was lifted from an article George Martin had showed him, and the perversity of it sparked a song idea. John got three pieces of music he had lying around and morphed them together. It has to be said that the song takes in more time signature changes and melodic shifts than a full album usually does, yet it doesn't even come to three minutes in length. Still, it's a brilliantly imaginative track and John's vocals are extraordinary here.

"I thought, What a fantastic, insane thing to say," John later said, somewhat chillingly in fact, when you consider the vile way he was taken from this earth. "A warm gun means that you've just shot something. It was put together from bits of about three different songs and just seemed to run the gamut of many types of rock music. I consider it one of my best. It's a beautiful song, and I really like all the things that are happening in it."

And with a perfect example of light and shade, Paul's wonderful Martha My Dear comes next, a magical piece of song writing. Famously an ode to McCartney's shaggy dog at the time, the melodies are cleverly intertwined and the brass and string arrangement is simply beautiful. John may have disliked Paul's lighter material, but in truth it's musical genius and without it The White Album could have been quite a depressing experience. Speaking of his dog Martha years later, Paul said "our relationship was platonic, believe me."

On that note, I'm So Tired follows the upbeat energy of Martha My Dear, with a frustrated Lennon desperate for some kip but too troubled to get any. He curses Walter Rally for his tobacco addiction, sounding fatigued and strung out. In fact he curses the whole world and he'd give you it all for a little peace of mind. There's a great simplicity and purity to the flow of the chords and the band play nicely on this one.

Acoustic splendour comes next with Paul's classic Blackbird, a pleasant foot tapper inspired by the start of a Bach piece that he and George would play as kids. Now it's become one of Paul's signature tunes, not far from Yesterday in terms of its legendary status. There's some lovely bird sounds too and Paul's acoustic playing is sublime.

Don't Pass Me By was Ringo's first self penned track for the band, although he got some help from the others. Although ragged in its arrangement, Ringo's voice sounds great and the melody is wonderfully catchy. Paul gets raucous on Why Don't We Do It In the Road, with Ringo on drums and Paul on piano. It's certainly a raw and unusual moment on this double set for an otherwise tuneful McCartney. John said it was one of Paul's best songs, weirdly enough.

The rather tiresome theory goes that within the creative framework of The Beatles, John Lennon provided the rough edged, acidic element of the band's sound, the more emotionally charged material. The very same cliché credits Paul McCartney with those foot tapping, infectious melodies, the catchy tunes and tirelessly optimistic world view. In a word, history has made McCartney the "Muzak Maker" and Lennon the unpredictable, quirky, soulful artist. It's well documented that this unfair summary niggles away at Paul and it's easy to see why.

Although John was undoubtedly edgier than Paul, it's a plain fact that some of The Beatles' rawest and most unusual sounds were directly influenced or thought up by Paul. Look at, for instance, Why Don't We Do It In the Road, that brief but suggestive declaration of sexual freedom, urging us all to do it where we may feel like doing it (the lyric itself was inspired by watching monkeys mating in India). Paul screams the line over and over, becoming increasingly wild and frenzied, almost like a pre-cursor to John's primal scream therapy days. It's neither melodically nor musically rich, and certainly not polished, as we are told all McCartney tunes are. In fact it's dirty, raunchy and much more the kind of thing you would expect from Lennon. The fact that John wasn't even present during the recording though (and in fact later expressed annoyance at not being invited into the speedy session), goes to show that not everything McCartney does is meticulously planned and mapped out to perfection. Some of it, quite clearly, comes from spontaneity and he is more than able to give us challenging material. It's full of John-isms that are hard to ignore.

John's saddening Julia ends the first record, an acoustic plucked moment of reflection; a message to both his dear departed mother and Yoko Ono, who is the ocean child he speaks so fondly of in the song. "Julia was my mother," John said of the song. "But it was sort of a combination of Yoko and my mother blended into one. That was written in India. On the White Album. And all the stuff on the White Album was written in India while we were supposedly giving money to Maharishi, which we never did. We got our mantra, we sat in the mountains eating lousy vegetarian food and writing all those songs. We wrote *tons* of songs in India." It's a quiet and reflective point in

the album, a romantic ode to his mother, as the first section calmly comes to a close.

The care free abandonment of Birthday opens the second record, a rocking feel good number destined to be played at every Beatle fan's birthday from now to eternity. That lovely rock and roll riff, oh so simple, is made all the more effective by the clattering Ringo back beat and the shouted, exuberant lyrics - of which there aren't that many. It's such an uplifting song, nothing to take serious or analyse, but to simply enjoy.

Yer Blues couldn't be more different of course, Lennon's depressing yet hard rocking version of the white man's blues. When he says he feels suicidal, we believe him. There's some weird, avant-garde guitar solos in this, and some pointy riffing. Easy listening it most certainly is not. This too was written during the meditative retreat.

"The funny thing about the [Maharishi's] camp was that although it was very beautiful and I was meditating about eight hours a day," Lennon later observed, "I was writing the most miserable songs on earth. In Yer Blues, when I wrote, 'I'm so lonely I want to die,' I'm not kidding. That's how I felt." Ringo said it was one of the band's best moments, calling it grunge rock of the sixties. "Just the four of us," he says in Anthology, "you can't top it."

Paul's beautiful Mother Nature's Son is a polar opposite. By now the album has taken in every mood and state of mind possible, yet the shifts are never awkward or jarring. The album flows beautifully, each track merging into the next seamlessly. In fact the running order, devised carefully by George Martin and the band, is a big part of the album's success as a piece of art.

The hammering clank of Everybody's Got Something to Hide Expect For Me and My Monkey is an exciting and joyous moment on the record, with some crunchy guitars against a hollering Lennon lead vocal and celebratory whooping in the background. "That was just a sort of nice line that I made into a song," Lennon later commented. "It was about me and Yoko. Everybody seemed to be paranoid except for us two, who were in the glow of love. Everything is clear and open when you're in love. Everybody was sort of tense around us - you know, 'What is SHE doing here at the session? Why is she with him?' All this sort of madness is going on around us because we just happened to want to be together all the time."

Then we're into Lennon's attack on his one time prophet and "God," the Maharishi, who he quickly became disillusioned with over false claims that he had forced himself upon some of the women in the meditation camp in India. This rumour was speedily fabricated by self proclaimed electronics genius Magic Alex, another one of Lennon's gurus, although this one was much sillier than the Maharishi... but may he rest in peace. In the original demo, he openly referred to the Maharishi, but chickened out and replaced him with the much funnier and more vague Sexy Sadie. There's some real grooving music in this one, some nice guitar interplay and a solid Ringo beat.

Although Lennon's rockier, more edgy moments are what you'd expect from him, Paul goes way against the clichéd, misread type with the most terrifying, heavy piece of music The Beatles ever cut - Helter Skelter. Although its very existence now is overshadowed by its links to the murders by odd ball nut job Charles Manson and his so called Family, the track itself must surely be the advent of Heavy

Metal as we now know it. After all, Ozzy Osbourne, singer with metal pioneers Black Sabbath, has always said The Beatles were the reason he ever got into music. Sure, there had been heavier music before this (some of those early Troggs and Kinks hits for instance), but this was the kind of doomy rock we didn't widely see until the 1970s.

John's Revolution 1 is fantastic, a song also released as a single in a more rocked up format. Here John is considering revolution, against a basic blues format structure. "I did the slow version (Revolution 1) and I wanted to put it out as a single," John remarked, "as a statement of the Beatles' position on Vietnam and the Beatles' position on revolution." Here, John's "count me out" of the destruction is more defiant, while on the single he sits on the fence, being both in and out The Left, whom John would become more friendly with in the coming years, were confused by his refusal to commit to the revolt. Politics aside, it's musically interesting, grooving along nicely at a good pace.

Cry Baby Cry may come as a precursor to the overshadowing apocalypse of Revolution 9, but it's a decent, often overlooked gem near the end of proceedings in its own right. It was Revolution 9 that grabbed a lot of the headlines though, a Yoko influenced piece of avant-garde oddness which Harrison also had a hand in.

"Yoko was there for the whole thing and she made decisions about which loops to use," John later explained, who had had his eyes opened by Ono's approach to music. "It was somewhat under her influence, I suppose. Once I heard her stuff - not just the screeching and the howling but her sort of word pieces and talking and breathing and all this strange stuff, I thought, My God, I got

intrigued, so I wanted to do one. I spent more time on Revolution than I did on half the songs I ever wrote. It was a montage."

Many Beatle admirers may associate the more experimental elements primarily with Lennon, like the tape loops, seeing as he later became viewed as the daring, brave, cutting edge artist following his pairing with Yoko Ono. But it was in fact Paul who first got interested in the avant-garde, name checking such figures as Stockhausen as far back as 1965, and toying around with his home tape loops way before John seemed interested in them. He even showed John the craft of it on his home tape set up. The truth is, Paul was out there on the scene of swinging London, delving deep into the latest trends and even making artsy short movies. John was reluctantly playing the dissatisfied house husband to Cynthia, "getting fat" as he said himself (although in the footage he doesn't look overweight at all, in fact he looks really healthy and cool), buying expensive toys to ease the boredom and lounging in the pool or lying in bed all day. Poet and musician Ivor Cutler, who worked with The Beatles on The Magical Mystery Tour film, said Paul's mind was like a constantly working machine, full of ideas and busy with meticulous calculation. McCartney was the driving force of the band in the latter part of the 60s; often the one to get them off for their backsides and working on new ideas. Still, once he was putting the hours in, few could equal Lennon's combination of raw wit and musical power. Once John was awakened from his waking slumber by Yoko Ono, he was the greatest.

Personally, I feel Revolution 9 should have been dropped in place of John's similarly mad but infinitely more enjoyable What's the New Mary Jane, one of his most imaginative, bizarre and funny songs

from this era. An underrated experiment in free form madness and crazy word play, thank god it finally got a proper release on Anthology 3. Still, I think it should have gone on to the White Album.

As the schizoid glory of this most mammoth of albums closes with Ringo bidding us all a sweet Good Night, you realise this is one of the most varied, off beat and challenging records ever to go into the mainstream. The fact it is one of the best selling records of all time makes what The Beatles did even more extraordinary. John shines throughout the record, giving it a sense of danger, menace and haunted beauty. This is the best work he ever did in The Beatles, and some of it could easily have fit on to his solo material.

JOHN AND YOKO:
THE ZAPPLE EXPERIMENTS

From the moment John met Yoko at her exhibition at the Indica gallery in November 1966, everything within the world of The Beatles changed. In Yoko he found a true kindred spirit, someone who understood him, a soul mate, a lover and a best friend. For John, meeting his one true love was a moment of monumental destiny. It was written in eternity that he should come across this woman, the being who would save him from oblivion and wake him to the wonders of life itself.

"That old gang of mine. That's all over," John said in a later interview. "When I met Yoko is when you meet your first woman and you leave the guys at the bar and you don't go play football anymore

and you don't go play snooker and billiards. Maybe some guys like to do it every Friday night or something and continue that relationship with the boys, but once I found *the* woman, the boys became of no interest whatsoever, other than they were like old friends. You know: 'Hi, how are you? How's *your* wife?' That kind of thing. You know the song: 'Those wedding bells are breaking up that old gang of mine.' Well, it didn't hit me till whatever age I was when I met Yoko, which was twenty-six. Nineteen sixty-six we met, but the full impact didn't... we didn't get married till '68, was it? It all blends into one bleeding *movie*! But whatever, that was *it*. The old gang of mine was over the moment I met her. I didn't consciously know it at the time, but that's what was going on. As soon as I met her, that was the end of the boys, but it so happened that the boys were well known and weren't just the local guys at the bar."

The dwindling interest John had in The Beatles is clear from 67 onwards, especially in the material on Sgt. Pepper. Though workman like and requiring little effort, Lennon arguably made the finest and sharpest contributions to the band's psychedelic phase. Consider I Am the Walrus, A Day in the Life and Lucy in the Sky with Diamonds. These are monumental songs that changed music and art was we knew it. if this was John not trying too hard, it was a testament to his power and abilities. His work on The White Album is much closer to what he would do in his solo career, especially on the later Some Time in New York City album; very John and Yoko, and very un-Beatles. It was clear by the off the wall experimentation on the White Album that John was very present, although heavily influenced by Ono too.

So, the year is 1968, and while The Beatles are still dominating the charts and the cultural landscape, not to mention the newspaper headlines, John and Yoko begin work on a trilogy of off the wall recordings.

Unfinished Music: Two Virgins is the first of these records, released around the same time as The Beatles' groundbreaking White Album in 68. It was recorded in a single night recording session at John's house while his wife Cynthia was staying away. As night grew into morning, John and Yoko had finished their album and made love for the first time, closing of their creative evening with an official union. Fans of The Beatles would more than likely have been horrified by the contents of it at the time - and the album cover with Yoko's boobs and John's plonker out - but the truth is it's actually quite interesting. Disturbing at times yes, yet a worthy experiment in bringing the avant-garde to the mainstream. Even though the record didn't make the charts, it built up quite a reputation and small cult following, which is funny considering the unsettling contents of it. Basically two long pieces of music, one on each side both lasting around 15 minutes each, it's the kind of thing to hear at least once, even if it's just for the novelty of hearing John and Yoko experimenting with something outside the pop and rock format. They clearly believed in what they were doing.

"When we got back from India, we were talking to each other on the phone," John later told Rolling Stone. "I called her over, it was the middle of the night and Cyn was away, and I thought, 'Well, now's the time if I'm going to get to know her any more.' She came to the house and I didn't know what to do; so we went upstairs to my studio and I played her all the tapes that I'd made, all this far-out stuff, some

comedy stuff, and some electronic music. There were very few people I could play those tapes to. She was suitably impressed, and then she said, 'Well, let's make one ourselves,' so we made Two Virgins. It was midnight when we finished, and then we made love at dawn. It was very beautiful."

John also spoke about the controvsery caused by the album cover, with a naked John and Yoko in all their... ahem, glory. "The thing is, I started it with a pure... it was the truth, and it was only after I'd got into it and done it and looked at it that I'd realized what kind of scene I was going to create. And then suddenly, there it was, and then suddenly you show it to people and then you know what the world's going to do to you, or try to do. But you have no knowledge of it when you conceive it or make it. Of course, I've never seen me prick on an album or on a photo before: 'What-on-earth, there's a fellow with his prick out.' And that was the first time I realized me prick was out, you know. I mean, you can see it on the photo itself - we're naked in front of a camera - that comes over in the eyes. I mean, you're not used to it, being naked, but it's got to come out."

The album is a work of art. If pop art had come about to act as visual art for the young pop fan (as opposed to classical music standing aside classic art), Unfinished Music was avant-garde sound for avant-garde art.

Unfinished Music No.2: Life with the Lions isn't quite as interesting for me, and seems almost cobbled together, although that was probably the whole idea of it. Documenting their new life together, they didn't believe that music had to have melody or hooks, as a lot of experimental musicians had been saying in the underground for years. John explained the concept behind it, commenting that it's

"saying whatever you want it to say. It is just us expressing ourselves like a child does, you know, however he feels like then. What we're saying is make your own music. This is Unfinished Music."

Cambridge 1969 is the recording of a live performance by Yoko and Lennon -Yoko screams and Lennon provides awful guitar feedback. There's a raw purity to it that you cannot help but admire and get sucked in by. The second side has a more mixed approach, with No Bed for Beatle John consisting of the pair singing out press clippings about themselves, acting out their own fame in an audio diary format. In this respect it was ahead of its time. The album closer is perhaps the most telling of all the numbers; it's 12 whole minutes of radio surfing, with a bit of chatter in between. The cover is great you have to admit, but the contents don't really encourage repeated listens, even if it is an admirable idea.

The third in their trilogy is Wedding Album, by far the least interesting of the three records in my opinion. Again, it's a form of diary and documentation, using tempo and speed changes on their voices. "It was like our sharing our wedding with whoever wanted to share it with us," John himself later explained. "We didn't expect a hit record out of it. It was more of a... that's why we called it Wedding Album. You know, people make a wedding album, show it to the

relatives when they come round. Well, our relatives are the... what you call fans, or people that follow us outside. So that was our way of letting them join in on the wedding."

Wedding Album received a critical kicking, and was the least successful of all three albums. Melody Maker were very critical, but John as amused by their negative write up and wrote the reviewer, Mr Richard Williams, a nice little note:

"DEAR RICHARD THANK YOU FOR YOUR FANTASTIC REVIEW ON OUR WEDDING ALBUM INCLUDING C-AND-D SIDES [STOP] WE ARE CONSIDERING IT FOR OUR NEXT RELEASE [STOP] MAYBE YOU ARE RIGHT IN SAYING THAT THEY ARE THE BEST SIDES [STOP] WE BOTH FEEL THAT THIS IS THE FIRST TIME A CRITIC TOPPED THE ARTIST [STOP] WE ARE NOT JOKING [STOP] LOVE AND PEACE [STOP] JOHN AND YOKO LENNON..."

While these Zapple experiments do deserve some attention for their sense of care free artistry, they aren't proper solo records as such. As art works they are unparalleled, and like beat poetry and novels, they have a raged, cut up charm about them. Now reissued on vinyl, the Lennon devotees won't have to splash hundreds of pounds on an original. They can be enjoyed for under twenty pounds these days. Well, enjoyed maybe isn't the word for these albums. Still, it's amazing to think that a member of the biggest band in the world were releasing material like this. Oh, the sixties...

THE BEATLES: THE FINAL CHAPTER

The last two years - 69 and 70 - in the Beatles career bore some mixed fruit, but this phase also gave us some Lennon gold, pure and simple The original 1969 release of the soundtrack to the band's animated film Yellow Submarine doesn't really count as a full on proper Beatles album in my view, given that George Martin's classical score takes up all of side 2. As nice as it is, it was lazy in a way of The Beatles to come up with a mere six tracks for the album, two of which were older songs already released widely in their own right (Yellow Submarine and All You Need Is Love). The other four are OK, but only one of them is really a contender for Beatles classicdom. Then again, the band were hardly interested in the cartoon itself - they

couldn't even be bothered to provide their voices, something they might have regretted after when they realised how good it was.

Hey Bulldog, a fiery Lennon nonsense poem set to rocking music is a fine number, with fantastic improvisations towards the end between Paul and John, barking and larking around. With a nice crunchy guitar riff and solo, it's one of their heaviest cuts, with booming bass and thudding toms by Ringo. All Together Now, Paul's song put in at the end of the movie, is a nice kid's tune, perfect for the film but merely a bit of a laugh on its own merit.

As for the two other tracks, both written by Harrison, they only really work when put into the movie and listened to alongside the breathtakingly weird and wonderful animated visuals. Only A Northern Song is perhaps among the least enjoyable Beatles tracks, a collage of out of key sounds held together over a loose rhythm section. It's All Too Much is good, for a while at least, but at over six minutes it simply becomes a bit of a bore. The fact that Lennon and McCartney had given Harrison clearing for two tracks, and he chose to provide these two lacklustre numbers, only goes to show how George was tiring of life in The Beatles. Psychedelic yes, but not that interesting today.

A much better release in my opinion is the 1999 release The Yellow Submarine Songtrack, which not only features the six numbers from the 1969 version, but also every other song featured in the film. All of them are of course available elsewhere, but the complete running order makes this a real Beatles classic. You get highlights from Sgt Pepper, and key tracks from Rubber Soul, also used in the cartoon, the best of these being Nowhere Man. It's almost like a greatest hits package. Although not seen as a proper Beatles release, a fact

reflected in its chart positions at the time, it's still essential listening for the Beatles fan and historian, even for Hey Bulldog alone.

By 1969, The Beatles were slowly dissolving, and as desperate as Paul may have been to keep the band going, there really was no hope. When Abbey Road was recorded, just after the Let it Be project had been scrapped and shelved for later inspection, the band were ready to implode. Still, even as they disintegrated before each other's eyes, they put aside their differences, regrouped with George Martin (who hadn't produced Let it Be in his traditionally reliable way) and cut some damn fine music, some of which is among the best they ever put on to tape.

Starting with Come Together, a vintage Lennon rock and roll tribute (in fact it was such a tribute that he lifted lines directly from a Chuck Berry number and later got a law suit shoved in his face for his troubles), Abbey Road gets off to a grinding, raunchy start. There's a satisfyingly crunchy, heavy McCartney bass line which collides with chunky, precise guitars and moody keys. It has to be, musically at least, one of The Beatles' best moments, the rolling toms just the kind of thing only Ringo could come up with; most rock drummers would do a straight beat to this. Lennon gives us more of his wonderful nonsensical poetry, against a funky back beat.

"Come Together was one of the last ones to be recorded," Harrison noted back in 1969. "John was in an automobile accident, so he was off for a period of time. Then when we got back, which was only a week or so before we finished the album, we did this one. I think he wrote it only a month or so ago, so it's very new. It's sort of twelve-bar type of tune, and it's one of the nicest sounds we've got, actually. Nice

drumming from Ringo. And it's sort of up-tempo. I suppose you'd call it a rocker. Rocker-beat-a-boogie."

Harrison himself then offers us what many believe to be his crowning Beatles moment, Something. Not the most popular of Beatle tracks, Maxwell's Silver Hammer was attempted but abandoned at the Let it Be sessions earlier in 1969. Here it's given a more crisp, stable performance, with trusty old Beatles minder Mal Evans clattering the hammer on the chorus. McCartney continues his storm through the record with Oh! Darling, a soulful waltz, boasting one of Paul's finest vocal performances from all of The Beatles' back catalogue. Despite the obvious fact that Paul's voice is perhaps the strongest element in the song, John later put his efforts down, although he admitted he loved the track itself. "Oh! Darling was a great one of Paul's that he didn't sing too well. I always thought that I could've done it better - it was more my style than his. He wrote it, so what the hell, he's going to sing it. If he'd had any sense he should have let me sing it."

Ringo's second composition for the band (after Don't Pass Me By on The White Album) is the lovely Octopus' Garden, a light childlike nursery rhyme given a simple yet effective musical arrangement. Clearly, Ringo was tiring of the tight atmosphere in the band and the tensions that were mounting. It juxtaposes harshly with John's tortured declaration of pure passion, I Want You (She's So Heavy). If Helter Skelter was the birth of metal, this is the next step towards utter chaos. John repeats the phrase over and over, that he wants this woman - Yoko of course - so bad that he can barely bring himself to say anything else. The whirlwind closing few minutes where the band grind through the dark, foreboding melody over and over again is

surely one of the most breathtaking moments in their discography, a shatteringly heavy stomp into filthy obsession. "Simplicity is evident in She's So Heavy," noted John a couple of years after recording the song. "In fact a reviewer wrote 'He seems to have lost his talent for lyrics, it's so simple and boring.' When it gets down to it - when you're drowning, you don't say 'I would be incredibly pleased if someone would have the foresight to notice me drowning and come and help me,' you just scream."

Again, continuing The Beatles' tradition of contrasting moods, Harrison's beautiful, idyllic Here Comes the Sun (penned while sitting in the garden with Eric Clapton) opens side 2 with understated bliss, making way for the mixed bag of goodies that is the rest of the album. Because is a haunting mystery, boasting some of the band's best harmonies since Rubber Soul. Even at such a late stage in their career, as things were crumbling from within, they were capable of being tighter than any set of musicians could possibly be. It's here that the classic Abbey Road medley starts to come to fruition. The wake of Paul's varied and wonderful You Never Give Me Your Money (an ironic take on the band's current legal difficulties with American manager Allan Klein slivering into the picture) gives way to the mutated cousin of Here Comes the Sun, John and Paul's Sun King. Clearly inspired by Fleetwood Mac's number one hit Albatross, the band play a mean and moody bit of atmospheric blues. John later called it garbage though, somewhat unfairly.

The Beatles come bursting with life into two up beat and rocking surreal John fragments, Mean Mr Mustard and Polythene Pam. Mustard is reminiscent of Wilfred Brambell of Steptoe and Son fame, who also played Paul's grandfather in A Hard Day's Night, but the

song is not inspired by him. It's basically a little short story lifted from an article John had read in the paper. Polythene Pam was inspired by a woman John had heard about who, as he put it, had "perverted sex in a polythene bag." Although brief, it's a classic John Lennon moment and very English in its delivery (John adopts a thick Liverpool accent for it).

There are some beautiful stirring strings towards the end, which arrive majestically, bringing the album into grander territory than ever before, and we know the end is coming near. This is the sound of history unfolding in your ears, of a world changing, as the band launch into the mass sing along of Carry That Weight. "I'm generally quite upbeat," Paul later said on the subject of the track. "But at certain times things get to me so much that I just can't be upbeat anymore and that was one of those times. 'Carry that weight a long time'-- like forever! That's what I meant... in this heaviness there was no place to be. It was serious, paranoid heaviness and it was just very uncomfortable."

It's a moment of true sadness on the record, the fact that all four members of the band were carrying the weight of being The Beatles on their backs. "He was singing about us all," John later told a visitor to his home during the making of the Imagine album. In a sense he was, and we can all relate to the weight of life, of the troubles and our responsibilities, especially as we reach around the age The Beatles happened to be when they cut this track. They were once boys, but now they were men.

The rocking finality of The End, with those three duelling guitar solos axing away at one another with sheer brute force and Ringo's iconic tom fills, represents one of the band's finest musical moments.

It is with those final fitting lines that Paul sums up the whole sixties ethos, and the message which The Beatles always tried to put across; to love each other and in turn be loved.

There were non album cuts in the latter phase that also stand out too. One notable single from this era was John's wonderful The Ballad of John and Yoko, a kind of travelogue of their adventures set to music. With only Paul and John playing, it wasn't The Beatles as such, and these days is often mistaken for a solo Lennon cut. It's something of a pre cursor to much of the mood of his solo work.

"It was very romantic. It's all in the song," John told Rolling Stone. "The Ballad Of John And Yoko, if you want to know how it happened, it's in there. Gibraltar was like a little sunny dream. I couldn't find a white suit - I had sort if off-white corduroy trousers and a white jacket. Yoko had all white on."

That wasn't it for The Beatles though, not just yet. Although originally recorded before Abbey Road, the Let it Be album wasn't mixed and released until later, in 1970 in fact, thus resulting in the rather messy end of The Beatles recording career. Had they put it out there when they had originally finished it, Abbey Road would have ended up as the end of their story and would certainly have been a more fitting, and tidier final chapter.

Although it has the reputation of being a bit of a stinker, Let it Be is at times just as strong as their earlier work. Any criticisms to be had are with the two dog eared interludes, the rather pointless Dig It, with a frantic Lennon listing entities and organisations at random over a repetitive rhythm, and Maggie Mae, a traditional song sung by John and Paul in thick scouse accents. The Phil Spector mix, which was done without the consent of Paul, who had by now attempted to get out of the Apple/Beatles contract to start his own solo career, often leaves a lot to be desired and for this listener at least, the later Let it Be... Naked, overseen by McCartney himself, is by far the stronger album. Firstly, it excludes the ragged Maggie Mae and Dig It, as well as getting rid of the snippets of studio banter and adding in the marvellous John ballad Don't Let Me Down. On top of this, there are some truly splendid mixes of several Beatles classics, here as raw and brilliant as I am sure they were intended to be, without angel choirs and mushy string sections.

On the original record though, opener Two of Us sounds like it was recorded today, vital and fresh still. The arrangement is bare and simple, with duelling acoustics, pumping bass and stomping drums. There's a nice feel to the Lennon and McCartney harmonies, although there is also a hint of darkness hanging over it.

Dig A Pony, which John later called a piece of garbage, sounds absolutely monstrous on headphones; the bass booming, the guitars scratching away and the vocal wild and exposed. The music is great, but the lyrics are nonsense as Lennon himself admitted. Across the Universe is much better, and definitely one of John's best on the record. Although it had been recorded earlier (in early 1968 in fact),

it had its place on a proper studio album. Just listen to that beautiful melody and those meaningful, dare I say "cosmic" lyrics.

Harrison's I Me Mine is a nice solid tune that took a bit of working on before it got together; this is evident in the Let it Be film, where it sounds awful and out of tune at points, while Lennon seems disinterested in recording it at all, dancing a care free waltz with Yoko across the rehearsal floor. Spector made the short track longer by cutting and pasting it to add a minute or so to it. To his credit, it works pretty well. The title track is another contender for the ultimate McCartney ballad, a majestic, almost religious song to his mother. While John had gone inward when addressing his mum, Paul becomes soulful and passionate, resulting in one of the band's most powerful moments. It shows the differences between the two men when considering a serious subject close to their hearts. Paul turned his thoughts of his mother into a transcendent masterpiece. John later said it was Paul's attempt to write a grand song like Bridge Over Troubled Water, but there is much more to it than that.

Although Lennon's sarcastic Goon voice pre-empts its majestic arrival, you can't help but smile at his wicked sense of humour and it takes nothing away from the track itself. I've Got A Feeling is a nice groovy number, with Paul taking the verses and John adding in a mantra like chant of conscious thoughts. There's a nice back beat to this and Billy Preston adds some nice touches here, as he does throughout much of the album for that matter. Perhaps a little desperately, the band revisited their old backlog of unused tracks during rehearsals for Let it Be. As well as doing old rock and roll covers for the hell of it to build morale in such a tense time, they dug this out, One After 909, a basic rocker written when they were still at

school. Although it's not very interesting on a musical level, it has a nice feel to it and the boys are clearly having fun playing together. It's also one of the only uplifting songs on the whole rather down beat set.

Again, it's the Paul ballads which fare the best though, such as the heartbreaking version of the Long and Winding Road on the Naked version of the album. There are no strings and vocal assemblage as on the original release, just the four Beatles and Preston; subtle, calming and quite simply one of the band's best moments. Without Spector's corniness (the Walt Disney version as some have called it), it's one of the strongest songs Paul has ever written. He dominates Let it Be and just think what the album would have been like had he not been so on top of his game. One thinks of the ten minute jam version of Dig It making the final cut, or worse still, the infamous epic scream session with Yoko howling and screeching over a god awful Beatles backing. Lennon could not have been less interested in being a Beatles at this stage, and this is very evident in the material.

And there you have it, the final studio album released by The Beatles. While not their best record (maybe their weakest alongside Beatles For Sale), there are still some very special flashes of brilliance on it and at times it raises itself up to an unprecedented level.

In 1970, Lennon was merciless in his declaration that band were over. "We got fed up of being side men for Paul," he said. "After Brian died that's what happened. Paul took over and supposedly led us." He was tired of the Beatle game, the people he saw as the hangers on and folk who were making a living from The Beatles. "People are saying 'Don't take this away from us! Don't take our portable Rome from us.'"

The dream was over. But a new dream was just beginning.

THE BEATLES ANTHOLOGY

Contributing largely to the reiteration of the fact that The Beatles really *were* the greatest band there had ever been, was the mammoth Anthology project which finally materialised in 1995. A three double CD set of Beatles outtakes and alternate versions was exciting enough for the millions of Beatles fanatics all over the world, but the fact it was accompanied by the ultimate rock documentary, the eight part Anthology series, was the icing on the cake. Interviewed throughout were Paul, George, Ringo, John (the latter in archival footage and audio recordings) and various Beatle related folk such as George Martin and old friend and head of Apple Neil Aspinall, all of whom contributed to the telling of The Beatles story.

The genesis of the documentary went back to 1970 when Aspinall started putting together a visual document of the group's history. Finished by 71, it sat on a shelf for years, referenced by Lennon in a 1980 interview, who said that the band were going to film a reunion concert for the movie's big finale. Of course, this tragically never happened, so the film was shelved again.

In the early 1990s Jools Holland was on board to interview the fabs for a new version of the movie, compiling interviews, footage and live performances. In retrospect it's a good job they waited, as The Beatles themselves were not even remotely involved in the original 1971 film but gave full support and time to the Anthology. Released two decades after the split, with most of the bitterness dimmed by the passage of time and the three surviving Beatles giving interesting insights into those hectic days, this was the definitive documentary on the group. There had been good ones before, in particular The Compleat Beatles, narrated by Malcolm McDowell and South Bank Show's The Making of Sgt. Pepper. This though, all 11 hours of it, was something else entirely.

For me it's good that we only get insights from those who were involved in the inner circle of the Beatles world. Had the film taken on a more traditional music documentary format, with critics and journalists included, it might not have been half as interesting. Even though the band, the Apple personnel and George Martin often recall tales differently from one another, it doesn't matter. In fact it makes it more relatable. How often do we all recall a memory completely different to how someone else recalls it?

The Anthology is my favourite music documentary of all time. I can re-watch it time and again, and it never gets boring for me. Of course it helps that the music it's documenting just happens to be some of the best music that's ever been created.

The outtakes, rough cuts and incomplete versions of most band's tracks are certainly not fit for an official release and never see the light of day, save for a few bootleg smugglers who might trade them back and forth online or under the counter. But then, The Beatles are

not most bands. Their scraps and demos have always been of interest, not just musically, but historically too. For decades people had been wanting to hear more of the original 1958 demo tape, the famous Decca audition and the alternative renditions of much loved classics and in 1995 they were treated to three volumes worth of them, adding up to six whole discs. The old material was exciting enough to most Beatle heads, but the fact that Paul, George and Ringo were going back into the studio to cut two new tracks with producer Jeff Lynne was enough to spin their heads. Using some piano and vocal demos recorded by John on his home tape recorder, Lynne cleverly made it able in mid 90s technology for the three surviving Beatles to sing alongside their fallen friend without it sounding tacky or cheap. Nowadays it would be easy to sample him in there with the new music, but back in 95 Lynne had a hell of a task on his hands.

The first new track was Free As A Bird, a strong song in its own right, which started off the first Anthology set. Featuring some beautiful Harrison solos, sturdy Ringo drums and lavish Paul and John vocals, the track certainly lived up to The Beatles name and became a hit single the world over. The second track, which they included on the second Anthology set, was Real Love, although it was nowhere near as good and didn't cause that many ripples. The third, another John song, was abandoned half way though according to Paul, because Harrison thought it was crap. "I'm gonna go back in one day with Jeff and finish it," Paul later joked. The Anthology CDs themselves were also massive sellers, reminding the world just how great The Beatles really were.

The first volume is full of little gems and some vintage interview snippets to act between tracks as a kind of loose narration through

the Beatles story (it falls by the wayside after Volume 1 though unfortunately). The Quarrymen recordings of 1958 are scratchy but essential for any fan to hear. Lennon sounds unbelievably youthful and we can hear his early love of rock and roll. Although the My Bonnie single where they backed up Tony Sheridan has been released before, it just had to go on this. Without it, the story of The Beatles just wouldn't have been complete. Sheridan is a so-so singer, but even then the band sound tight and together. It's Disc 2 where things get interesting though, with different takes of various well known and loved songs, with banter in between taking you right inside the recording studio.

It has to be said that for me at least, Anthology 2 is the best of the lot, as it spans the most important years of the band's existence. It starts in 1965 with alternate takes of classics like Yes It Is and the smashing single I'm Down. There's lovely versions of You've Got to Hide Your Love Away and Yesterday, while we are even treated to live performances in Blackpool and New York in August of 1965. The version of I'm Looking Through You is crunchily satisfying and better than the one on the released album. Although a Beatle newcomer might be confused if you just popped the Anthology sets on without telling them much about it, even a casual Beatles fan can find something worth their time here. Going through 1966, there are different takes on key tracks from Revolver, including the first version of Tomorrow Never Knows, which is possibly even more mind bending than the one on the released record).

On the second disc of set 2, we move towards the end of 1966 with John's original demos of Strawberry Fields Forever. Revealed is the bare and fragile voice of Lennon, the dreamy words and the simple

melody line. Similarly, a version of Penny Lane offers us Paul's gift with effortless magic. The stripped, embryonic version of A Day in the Life is perhaps the highlight of the whole set, with John's voice untouched and unspoilt, as George Martin said on the documentary "sending showers down the spine." A version of I Am the Walrus without the overdubs is also very revealing, unearthing the swampiness of the slightly seedy track.

Anthology 3 is quite peculiar, as most of the material from the era it covers - 68 to 70 - was actually released to the public in a sparse manner lacking in production fanciness. Still, we are given invaluable glimpses into the writing and recording process of The Beatles. An early take of Helter Skelter shows you how much it moved on before becoming the terrifying proto-metal masterpiece we all know, while some of the legendary acoustic White Album demos are included. Although they have been bootlegged for years, they sound great here amidst the other early takes. John's Mean Mr Mustard and Polythene Pam segments sound fantastic with just his voice and guitar.

Perhaps unsurprisingly, the Anthology release was seen as an indispensable treasure trove for the Beatle fanatic. Combining the DVD boxed set, the six discs and the huge, lavish book that surfaced five years later, this has to be the best archival release of all time. Although there are a lot of Beatles compilations out there, I feel it's better to discover each studio album one by one and then delve deep into Anthology. That way, you'll get a complete experience of the greatest band in history.

THE BEATLES: PAST MASTERS

As previously mentioned, there are numerous Beatles compilations out there, the best of them being the red and blue hits collections released firstly in the 1970s, and of course the more recent album of Beatles Number Ones. If you already have the studio albums though, you won't really need them, as many of those hits are on the albums themselves. What you will need though, as a proper companion to the studio records, are these two volumes of Past Masters, which features essential John Lennon gold. Released in 1988, nearly twenty years after the implosion of The Beatles, it was a long time coming for a lot of the die hard fans out there. Finally, all the singles, B sides and rarities not previously out there on CD were now together in all their glory. If you want to skip the vast amount of compilations out there (although some, like The Beatles Ballads, are worth having on

vinyl just for the artwork alone), why not go straight for Past Masters instead?

The first volume takes in all the energetic Beatlemania material, starting quite understandably with their first hit, the single version of Love Me Do. Early chart storming singles like From Me To You, the beautiful Thank You Girl and She Loves You highlight the band's early dynamic sound, and as Paul later noted, their knack of connecting with their female audience, whom they continue to address on all these early gems. While the obvious Beatles classics punctuate the set, the B side buried treasures are all here too, and it has to be said they are even more interesting. This Boy, the flip side to their genuinely exciting single I Want to Hold Your Hand, is a gentle ballad sung by Lennon with feeling and measured emotion. It's a beautiful song, buried in their vast canon. The German versions of She Loves You and I Want to Hold Your Hand are good fun, but don't really warrant many repeated listens. Long Tall Sally (from the EP of the same name) is a Little Richard song most R and B bands did at the time, and is of little interest, McCartney's excellent vocal aside. I Call Your Name (also from that EP) is an overlooked Lennon bit of gold. A couple of their finest numbers from this era come next, the Lennon sung contentment of I Feel Fine and McCartney's own ecstatic take on the rock and roll classic format, She's A Woman. Perhaps they save the best until last though, the 1965 B side of Help, the high energy I'm Down (another one played excellently, and with plenty of humour, at the Shea Stadium concert).

Volume 2 is even better from the word go, although the first set is jammed full of must have material. Day Tripper, their 1965 single, is one of their most iconic numbers from the first part of their career;

that infectious riff, the rolling Ringo fills and tight McCartney and Lennon harmonies make it classic Beatles. Its double A side flip, We Can Work It Out, is a sensitive McCartney relationship song, highlighting complexities of his union with Jane Asher. This period was full of slightly sad love songs for Paul, hinting that his young love with Asher was slowly crumbling as they drifted apart. After all, they mixed in very different circles; Asher in the theatre world, McCartney in the pop scene. Still, the melancholy McCartney always penned a genuinely enjoyable and poignant song of mixed up love.

Paperback Writer is musically very interesting, in that it sounds both sparse and full at the same time. There's a chunky guitar riff and a zooming bass, with a driving Ringo beat and falsetto backing vocals. Although whenever they played the song live it was nearing on chaotic (by their own admission, they could never really nail the harmonies in concert), on record it's a gorgeous slice of pop. Again, it showed the creativity McCartney was capable of. Its flip side is the fantastic and moody John offering Rain, highlighting the ludicrous behaviour of the English, who run from the rain, yet hide from the sun, slipping into the shade. Musically it's fantastic, and Ringo in particular is at the top of his game here with some fruity fills and loose hat work. Today, the song sounds like an Oasis single and could almost be the one Beatles song that Oasis seemed to have based their whole catalogue on.

The set then slips all the way past 1967, given that Strawberry Fields and the other singles from that year had already been issued on other released discs (the brilliant Magical Mystery Tour CD). So it's straight through to 1968's more earthy and back to basics Lady Madonna, a lovely McCartney stompy piano piece with some great

brass and guitar duelling. Its B side, Harrison's The Inner Light, is fantastic and should really have made its way on to an album (the White Album maybe, seeing as the record lacked any of Harrison's highly listenable detours into Indian music).

Its B side is the marvellous Revolution, the electric version which John had wanted as the single (everyone opted for Hey Jude instead). Although there are three Beatles tracks based around the Revolution idea, this is the best (the experimental musique concrete piece is also interesting too). There's the single version of the band's iconic Get Back (famously played on the roof of the Apple Corps building) and its B side, in my view the far superior Lennon classic Don't Let Me Down. Its lack of inclusion on any album at the time (it was later put on to Let it Be... Naked as previously stated) is one of the band's biggest crimes, and it's even more unbelievable that it was reduced to B side status. Staying mostly on two chords (save for the middle eight segment), Lennon explains how no woman ever did for him what Yoko could do; it's raunchy, passionate and totally heart felt.

The alternate version of Across the Universe, used on the Wildlife charity record No One's Gonna Change Our World, is both stirring and haunting, one of Lennon's loveliest harmonies. The recording of the backing vocals has gone down in Beatles folk lore. Lizzie Bravo was a super Beatles fanatic who used to stand outside Abbey Road to catch glimpses of her heroes when they were going in and out of the studio. "I went from the airport to the hostel to leave my bags and straight to Abbey Road," Lizzie tells me on her journey from Brazil to the UK to spot the fabs, "where my friend Denise had seen them going in. Denise is from Rio, like me, and she had the idea of us going to London to see the boys and convinced her parents and mine

to send us - she arrived about a month before me and found out everything we needed to know. They were recording Sgt. Pepper. I saw the four Beatles, Mal Evans and Brian Epstein the night I arrived in London, as they left the studios. John was the first I saw."

One day, they were invited inside to help with a track. I asked Lizzie what it was like helping out on Across the Universe. "Amazing," she says. "My friend Gayleen and I were used to seeing them almost every day, so we remained calm and enjoyed every minute. They were truly nice to us, the mood was very pleasant. They were funny and made us laugh. John and Paul told us to sing "nothing's gonna change my world" at certain points in the song. They were definitely much more "normal" than superstars today."

It all closes with the hilarious joke number You Know My Name (Look Up the Number), one of the band's funniest studio goofs which had been developed in the past but wasn't released until 1970, lightening the mood of its heavy A side Let it Be. When considered, the two Past Masters collections feature some of the band's finest work and they cannot be simply side lined in The Beatles' discography.

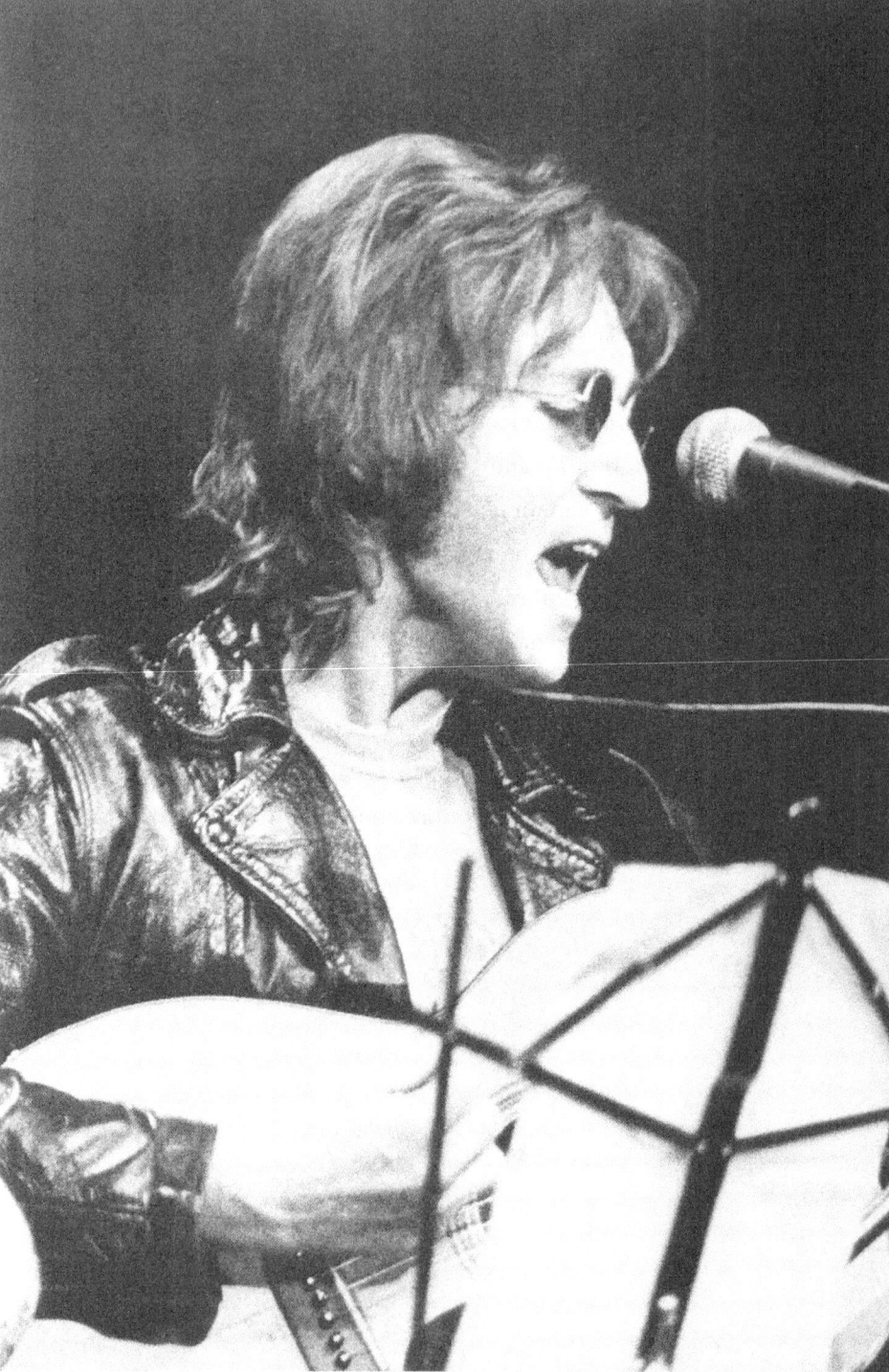

JOHN LENNON: GOING SOLO

The Beatles had become a ball and chain for John Lennon, or more specifically for John Lennon and Yoko Ono. They were, after all, the ultimate artistic couple now, making experimental albums and films, with cutting edge performances and ideas coming at an alarming rate. They were on the edge of the mainstream now, creatively at least, while still grabbing mainstream press, much of it nasty and derogative. In fact, some of the press were even openly racist towards Yoko. They were hurt, victimised and ridiculed.

While still a reluctant yet semi-active member of The Beatles, John and Yoko held their infamous Amsterdam and Montreal bed-ins for peace, where the couple stayed under the covers for what felt like a life time. Insistent on the fact that if it took for John and Yoko to look like clowns to get people talking about peace, it was worth it. Although they did other surreal and playful peaceful protests, this is

the one that caused the most controversy and grabbed the headlines. In retrospect, its funny to think that anyone could have been offended by a married couple just lying in bed for a good cause. Today, their acts are playfully funny and quite beautiful.

"There were we like two angels in bed, with flowers all around us, and peace and love on our heads," Lennon reflected. "We were fully clothed; the bed was just an accessory. We were wearing pyjamas, but they don't look much different from day clothes - nothing showing."

These protests, however erratically and wrongly received by the press, were not only an extension of John and Yoko as figures, but also an extension of their music and art. Their films, their songs, and their words were all part of the same thing. John and Yoko catalogued and documented their whole existence in various forms, music being just one of them. The Beatles were becoming more and more of a limiting outlet for John's ambitions, so much so that he was putting very little effort into the group and much more into his and Yoko's artistic experiments. Three minute songs, the pop single treadmill and having to compete with Paul for vinyl space was now getting frustratingly tiresome. John wanted to get out there on his own, with Yoko by his side at all times.

Give Peace A Chance was written and recorded during this Montreal bed-in. It quickly became an anthem for world peace (and a pretty nifty slogan for it too), a hippie theme song for the whole world to embrace. Although musically repetitive and bare (just Lennon on guitar with a chorus reciting the refrain with him), the song has an honest power about it that ensures it transcends the ages and stays relevant and beautiful to this day. Accused of preaching too much by none other than Paul McCartney (he'd later put these

theories on record), Lennon claimed he was doing anything but preaching, only offering suggestions and possible options for us all to consider, especially the suits and powers that be. "It wasn't like 'You *have* to have peace!' Just give it a *chance*," he said in his final interview. "We ain't giving any gospel here - just saying how about *this* version for a change? We think we have the right to have a say in the future. And we think the future is made in your mind.

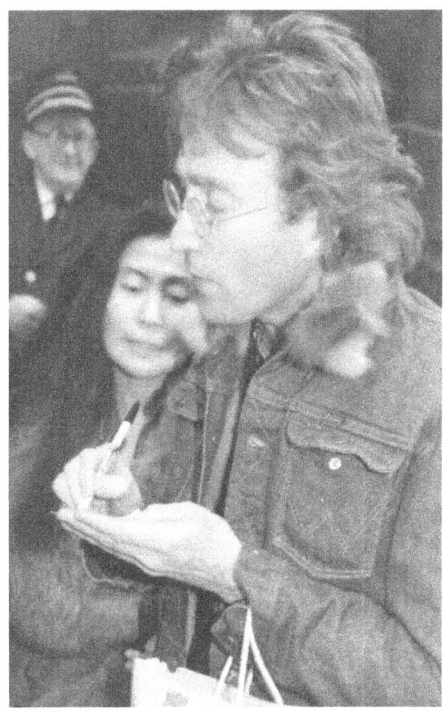

Lennon's musical career went on to more interesting areas. Less catchy, but even more interesting, was his Top 20 October 69 single Cold Turkey, a rocking slice of anguish as a result of his and Yoko's brief heroin addiction, a substance which John claimed they were hooked on to self medicate themselves against the cruel critical backlash against Yoko. With a stonking riff, chunky drums by Ringo and a thumping Klaus Voorman bass, musically it's a real treat (like a more sinister White Album outtake) and lyrically its unflinching power becomes overbearingly disturbing. When John sent back his MBE to Buckingham Palace in November, although it was for Britain's involvement in the "Nigeria-Biafra thing," he also joked that it was

due to "Cold Turkey slipping down the charts." Beatle mop top light hearted fun it definitely was not, but a classic Lennon single all the same.

"Cold Turkey is self-explanatory," Lennon told Rolling Stone in 1980. "It was banned again all over the American radio, so it never got off the ground. They were thinking I was promoting heroin, but instead... They're so *stupid* about drugs! They're always arresting smugglers or kids with a few joints in their pocket. They never face the reality. They're not looking at the *cause* of the drug problem. Why is everybody taking drugs? To escape from *what?* Is life so terrible? Do we live in such a terrible situation that we can't do anything about it without reinforcement from alcohol or tobacco or sleeping pills? I'm not preaching about 'em. I'm just saying a drug is a drug, you know. Why we take them is important, not who's selling it to whom on the corner."

At the end of 69 came the live album, Live Peace in Toronto 1969, a stunning set recorded at a festival at Varsity Stadium, which saw Lennon backed by Yoko, Alan White, Eric Clapton and Klaus Voorman. It was arranged in a speedy, spontaneous manner with no rehearsal save a couple of brief run throughs of songs on the plane over to Toronto. Though understandably rough, it has an appealing punky edge to it. Stand outs include Don't Worry Kyoko, Yoko's personal diary song, and a blistering Yer Blues. Rock and roll classic Blue Suede Shoes sounds primitively wonderful too, with some amazing Clapton soloing.

Meanwhile, in his run of stunning singles, Lennon released Instant Karma with the Plastic Ono Band, a powerful, catchy and unforgettable sing along that was a hit in February of 1970. Written

speedily at the end of January (inspired by Yoko's former husband, the artist Tony Cox, who was having a conversation about "instant karma"), Lennon lifted the chords from his own All You Need is Love, itself an impulsively written track, intended also to give a direct message with simplicity. With loose, exciting drums from Andy White, the song drives along solidly, with Harrison's guitar and Voorman's bass upping the energy. It's infectious, stirring stuff and highlights just how strong Lennon's song writing was when he was feeling inspired. It was a Top 5 hit for Lennon, proving that he had really arrived as his own entity.

"Everybody was going on about karma, especially in the '60s," Lennon told David Sheff, "but it occurred to me that karma is instant, as well as it influences your past life or your future life. There really is a reaction to what you do now. That's what people ought to be concerned about. Also, I'm fascinated by commercials and promotion as an art form. I enjoy them. So, the idea of instant karma was like the idea of instant coffee: presenting something in a new form. I just liked it."

Instant Karma was as catchy as Lennon got, a Beatlesy chorus coupling with a vibrant sense of melody and musicality. However, by the year's end, John will have unleashed a full length solo album, a set of bleak, disturbing and at times upsetting songs that came from his inner soul, and shocked Beatles fans the world over with their raw intensity. Beatle John was no more...

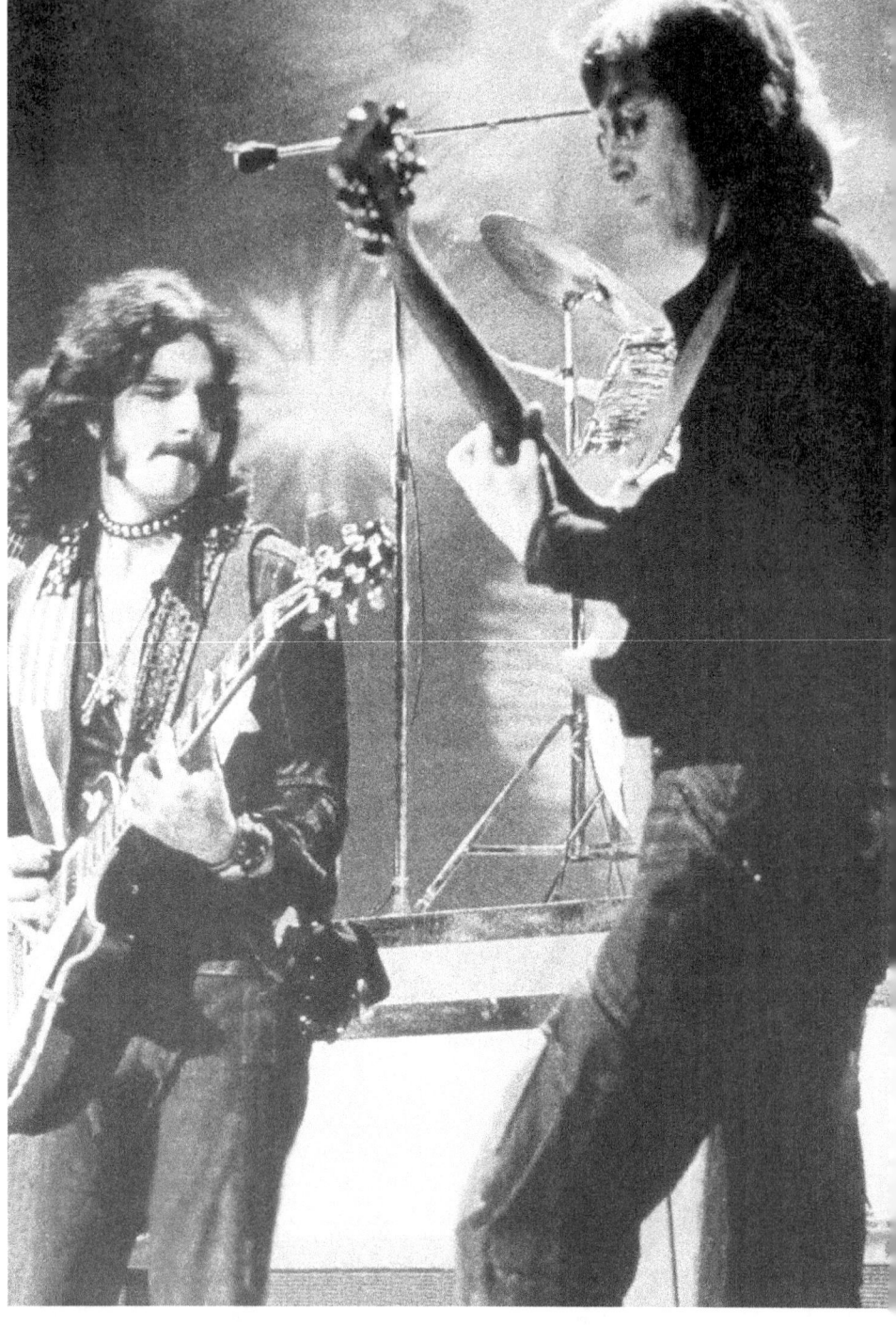

JOHN LENNON/PLASTIC ONO BAND

"I'm a cinema verite guitarist, I'm a musician and you have to break down your barriers to hear what I'm playing."
- *John Lennon, 1970*

Although he had released solo albums in the sixties, they were more of an experimental nature than actual albums of songs. The two volumes of Unfinished Music (Two Virgins and Life with the Lions) and the Wedding Album he made with Yoko Ono are interesting as historical documents, but let's face it, without Lennon's name on the sleeves they would have been forgotten years ago - not that they are particularly remembered outside Beatles circles mind you. His first proper solo album then is the raw, enthralling, ultimately painful and gutsy John Lennon/Plastic Ono Band, produced by John, Yoko and Mr Phil Spector. Although it was a million miles away from the

catchy hooks of The Beatles, it's an undeniably effective album, and anyone in their right mind should have seen that this was worthwhile art. Just as Yoko and John had been making a kind of public diary in their frequent appearances, in their art and their avant-garde recordings, he continued that trend here, putting down his most personal, bare and stripped music to date.

Essentially, Lennon cut the safety umbilical cord of The Beatles away with this album; and not with scissors, but with gnarled, angry teeth. Undergoing primal therapy with Dr. Arthur Janov, Lennon was able to get to the root of his own inner torment and exorcise it with external emotion. As both song writing tool and psychological healing, primal scream therapy was essential in John's development as a man and artist., He was able to overcome certain issues from his past and get them into song.

"Arthur Janov's thing is to feel the pain that's accumulated inside you ever since your childhood," Lennon told The Red Mole. "I had to do it to really kill off all the religious myths. In the therapy you really feel every painful moment of your life - it's excruciating, you are forced to realise that your pain, the kind that makes you wake up afraid with your heart pounding, is really yours and not the result of somebody up in the sky. It's the result of your parents and your environment. As I realised this it all started to fall into place. This therapy forced me to have done with all the God shit. Most people channel their pain into God or masturbation or some dream of making it. It's facing up to reality instead of always looking for some kind of heaven."

Beginning with a child like scream of "Mother!" it is instantly apparent that we are in the midst of Lennon overcoming, or

attempting to over come, childhood traumas, like the loss of his mother twice (firstly abandoning him and then dying) and the neglect from his father. Ringo's solid drums keep the pace going, while old friend Klaus Voorman lends his understated talents to the bass again. Lennon stabs sparse chords on the piano, his voice up front and pained. It's a beautiful melody and of course when he takes on the primal scream towards the end, the song becomes slightly disturbing, but all the more powerful still. Beatle fans must have been pretty shocked when they put the needle on the record to be greeted with an agonised Lennon screaming out the bad feelings from within. It was probably that reaction which Lennon expected. Yet there is a genuine beauty to it that would have been lacking had he opted for an overly melodic, richly decorated piece of traditional song writing. This is utterly real, and it's almost unbearable to hear his inner demons being laid out before the world.

If listeners were slightly worried that the whole record was all of this nature, they must have been pleased by the second track, the more pleasant Hold On, with its smooth percussion, funky bass and lovely guitar lines that match the sweet vocal perfectly. It's a superb song and the fact he claims "it's gonna be all right" certainly eases you into the rest of the record. It's a surprisingly varied set actually, the misconception being that it's a relentless, constantly downbeat attack on the senses. Though not polished by any stretch, this is a fine piece of art. The lighter moments, such as this, are much welcome shades in the whole painting.

Of course, you are lowered into a false sense of security with the next track, the red raw, ragged and stripped down I Found Out; its jagged guitars, thumping bass and clattering drums like a dagger

through the ears. The sparsely coloured sound of the arrangement mirrors much of the rest of the album and though there is no George Martin fanciness, Phil Spector still manages to get a decent sound, as purposely skeletal as it is.

Speaking to Rolling Stone in 1971, he was utterly proud of the record. "I think it's the best thing I've ever done," he proclaimed at the beginning of the interview. "I think it's realistic and it's true to the me that has been developing over the years from my life. I always wrote about me when I could. I didn't really enjoy writing third person songs about people who lived in concrete flats and things like that. I like first person music. But because of my hang-ups and many other things, I would only now and then specifically write about me. Now I wrote all about me and that's why I like it. It's me! And nobody else. That's why I like it. It's real, that's all. There's no bullshit."

Almost like Lennon's theme tune, Working Class Hero is a vicious, savage attack on the state's control over the everyday man and he sings it with such venom that it makes you want to stand up and rebel against this most unfair system of ours. He wasn't afraid to take on the man and in doing so, he also put in a couple of naughty words. Asked by Rolling Stone if he did it deliberately, Lennon replied "No. I put it in because it fit. I didn't even realize that there were two (F words) in the song until somebody pointed it out. When I actually sang it, I missed a verse which I had to add in later. You do say "fucking crazy"; that is how I speak. I was very near to it many times in the past, but I would deliberately not put it in, which is the real hypocrisy, the real stupidity."

Working Class Hero is an anthem for the everyman, as vicious a put down for the state as there ever was one. Singing alone with his

acoustic, John sounds at his most honest, angry and arresting here, demanding you take in every word and not get distracted by any musical frills. He was making a point and you couldn't help but listen to the man. Never have we heard such a bold and daring man in the mainstream field of so called pop music.

Isolation is a fantastic and haunting piano ballad, with Lennon sounding ghostly and other worldly. Ringo's solid snare is muffled and satisfyingly chunky, while John gives a wonderful, understated vocal effort. The words are wonderful too, stripped of all metaphors and surreal gobbledygook. If John and Yoko felt isolated by the way the press were victimising them, he put this across marvellously, and perhaps eased his own inner frustrations.

Remember has a satisfying, sparse crunchiness to it, those lovely stomping piano chords descending doomily under a fine Lennon melody. Again, Voorman and Starr keep it basic, making room for John's vocals. "It was incredible," Ringo told Uncut about the sessions and the wonderful chemistry in this three piece. "John, Klaus and I. One of the finest trios I ever heard. We did it like a jam. We knew John had the songs and we'd kick it in and felt where it should go." Starr states that their familiarity as a group worked to their advantage: "We knew Klaus anyway. John and I really knew each other, so we were psychic where the atmosphere was going to go. It's one of the best experiences of being on a record I have ever had,"

Love is one of John's most beautiful and sublime songs, a simple, straight forward and refreshingly honest piano/vocal piece. With that hauntingly stunning voice, he encapsulates everything about the enigma of love and what it is to be safe amidst its warm glow. It's that

voice that reaches out for your soul, every crack and break in it revealing more of the brave and honest human John so clearly was.

Well Well Well is pure punk rock thrills, a jagged aural attack by the trio. Listen to those spiky edged guitar lines, the hammering bass and thudding drums, and you realise this is among the heaviest stuff John ever made. The double tracked vocal is meaty and liberating, but the instrumentation takes it. Ringo's drums are loose, Voorman adds the slabs of bass and Lennon adopts his Revolution style distortion. Like a punch in the face, the aggression is up front.

Look At Me is another private little demo style piece, basic and pretty. His double tracked vocal takes centre stage, whereas one can hear shades of White Album era Lennon in the guitar plucking. Importantly, John never flinches away from the difficult areas on this record. In God, perhaps the album's ultimate statement, he laid The Beatles to rest by insisting he no longer believed in them. He just believed in himself and Yoko, insisting that the dream was over, breaking millions of hearts when proclaiming so. Of course, Lennon didn't just single out The Beatles as something he no longer believed in. Elvis and Dylan got it too. But it wasn't so literal. He meant for us all to believe in ourselves, as opposed to false idols and gods.

"I don't know when I realised I was putting down all these things I didn't believe in," he said to Rolling Stone. "I could have gone on, it was like a Christmas card list - where do I end? Churchill, and who have I missed out? It got like that and I thought I had to stop... I was going to leave a gap and say, just fill in your own, for whoever you don't believe in. It just got out of hand. But Beatles was the final thing because it's like I no longer believe in myth, and Beatles is another myth. I don't believe in it. The dream's over. I'm not just talking

about The Beatles is over, I'm talking about the generation thing. The dream's over, and I have personally got to get down to so-called reality."

John also explained his inclusion of the sad and disturbing My Mummy's Dead, which closes the LP on a dark note, to Rolling Stone. "Because that's what's happened. All these songs just came out of me. I didn't sit down to think, I'm going to write about Mother or I didn't sit down to think I'm going to write about this, that or the other."

Never before or since has there been such a precise, honestly personal, exposed and brave record. Nowadays we are presented with supposedly personal albums, statements from "artists" who claim to be baring themselves nude with minimalism. However, with most of these products, there is a layer of sheen and polish that hides the real truth, if there even is one. The PR machine of the 21st century ensures that an album as intense and disturbing as Plastic Ono Band would not see the light of day in the mainstream. This would be demo material, and the label would no doubt get some hip new big name in to sharpen it up and sand down the rough edges, to take the personality out of it. This is not a pretty album, though it has its moments of battered beauty. It's real, and that's a word so over used that it seems daft to even cite it as a descriptive tool for such a masterpiece as this. But real is the best way to summarize the work laid down here. It's not perfect, and John would not have wanted that. It's art, in the truest sense, as far away from being a piece of saleable product as such a global megastar as John Lennon could have got, having just left the biggest band in the world. That in itself - the fact that John was just out of The Beatles and chose to expose himself so brutally - makes the album all the more remarkable. A classic.

IMAGINE

While Lennon may have sounded like he was losing interest in recording with The Beatles in the latter days - especially when you listen to Let it Be - in his solo career from the word go, he was a man whose every lyric and note was put across as a statement in itself. On most of Lennon's albums, not a single second is wasted. As dark as some of his work may be, it's in the flaws, the dints and the battered spirit that Lennon appeals to you the most.

When it comes to Lennon's solo career, people will undoubtedly go straight for Imagine, released a year after his official debut; not just because it features his most timeless, beautiful and iconic track, Imagine itself, but also because it's his arguable peak as a solo artist. The title track is close to holy status now. As soon as it begins, you know you are in the presence of something special; that simple piano tune, the perfect melody and the pure voice. Regardless of what you

think of John's pondering statements, the song itself is very moving, the music subtle, lacking in schmaltz but still going straight for the heart as the shivers go up and down the spine. I can think of few finer ways to start off an album.

From the word go though, it's clear that Imagine is a completely different record to Plastic Ono Band, even if the recording set up was similar. True, Spector has more control here, and it's heavy on his characteristic use of reverb and production fanciness. Despite all this, it's still Lennon through and through, and one feels privileged to be able to get a glimpse into this special soul of his.

There is a moment in Gimme Some Truth, the documentary on the making of the record, where John introduces the group to his new song, a little ditty called Imagine. Casually he sits down at the piano and goes through it with no fuss. His voice cracks, as it's just a little run through. He's so laid back here it's stunning, and he even adopts a corny, jokey American accent towards the end. "That's the one I like," he says, finishing the song and turning to the gathered musicians. For such a monumental song, one of the most loved and treasured of all time in fact, it's kind of unbelievable to imagine (careful choice of word there) that it had such a humble birth. Alas, this is the magic of John Lennon.

Proving that she was a major influence in his life, John got the original idea for Imagine from Yoko's book Grapefruit, first published in 1964. Lennon later commented that he should have given her equal credit but he was, in his own words "a bit more selfish, a bit more macho and I sort of omitted her contribution." Although Lennon has called the song a bit communistic, he never was a communist himself, but simply a man considering a world

without walls and dividers, without religion and conflicting beliefs to create the kind of horror we have seen for centuries. In a world growing more terrifying by the month, Imagine still means a lot. Following the horrific terrorist shootings at the Paris Bataclan in November 2015, pianist Davide Martello drove 400 miles to play the song outside the venue before the gathered media and crowds. Sometimes, a song like Imagine can say so much more than any speech ever could.

"The concept of positive prayer," Lennon mused to Rolling Stone in 1980. "If you can *imagine* a world at peace, with no denominations of religion - not without religion but without this my God-is-bigger-than-your-God thing - then it can be true ... the World Church called me once and asked, "Can we use the lyrics to Imagine and just change it to 'Imagine *one* religion'?" That showed me they didn't understand it at all. It would defeat the whole purpose of the song, the whole idea..."

Crippled Inside is a mock country and western song, again with Lennon's sharp wit dead centre as he explains no matter what you do, you can't hide the rot within if you're all messed up. Musically it's joyous stuff, stamping along beautifully with some fine percussion, piano work and slide guitars. It leads into another one of Lennon's finest ballads, not only from his solo career, but from his discography as a whole; his timeless Jealous Guy. Another gorgeous piano melody, it's a heartbreaking song with some deeply honest and confessional lyrics. Lennon wasn't afraid to admit his flaws, but the fact he did it to such wonderful tunes makes you want to forgive his wrong doings. There is a brittleness to his voice which cuts you up

131

and it's when listening to this material that you can't help but feel saddened he was taken from us too soon and so cruelly.

"My song, melody written in India," John said in 1980. "The lyrics explain themselves clearly: I was a very jealous, possessive guy. Toward everything. A very insecure male. A guy who wants to put his woman in a little box, lock her up, and just bring her out when he feels like playing with her. She's not allowed to communicate with the outside world - outside of me - because it makes me feel insecure."

If you listen to McCartney however, the song was supposedly aimed at him. "He used to say, Everyone is on the McCartney bandwagon," Paul told Playgirl in 1985. "He wrote 'I'm Just a Jealous Guy,' and he said that the song was about me. So I think it was just some kind of jealousy." Whether about Paul or not - it is a possibility I suppose, but a little egotistical of Paul to see himself in the lyrics - it's irrelevant in the song's immortal role as a poem for the ages, and one painfully relevant to every human being in the world. This is exposed writing, and there is little enigma involved. Unlike a close contemporary like

Bob Dylan, Lennon wore his heart on his sleeve. What you saw was what you got. While Bob's vagueness may make him more of an appealing mystery - a magician of sorts - there is a refreshing openness to Lennon's work that gets to you in a more soulful way, rather than the surreal poetics of Dylan's work.

Again, there's the flip side to the Lennon dynamic, and on Gimme Some Truth he demands for the world to cease the relentless lies against a hard rocking back beat. It's rock and roll John again, only this time he's enraged by the injustice and the bullshit we are fed. The politicians are belittled here, nothing more than dirt to him, as he spits out the venom and contempt, going straight for the throat. There is similar nastiness evident in How Do You Sleep?, his snarling, arrogant attack against McCartney - and this one really is about him, no question. When an album contains a song urging for peace, namely the transcendent and anthemic Imagine, then goes on to the unforgiving verbal violence of this track, you only relate to John more. He is human after all and not many artists, especially these days, would be comfortable in showing you the least savoury side of their personality alongside the holiest aspects. After all, nothing is black and white in life. Musically though, it's still pretty exciting and whether he meant the words or not, it is still a classic number.

Importantly, John's childish lyrics are rather daft and defensive in retrospect, but they *were* a reply to Paul's attack on Lennon and Ono on his Ram LP. His rantings against Paul living with straights are ludicrous too - Paul amusingly wondered what was wrong with straights anyway - and the whole song has a bitterness to it that is ever so regretful. "So what if I live with straights?" Paul asked in 1971. "I like straights. I have straight babies. It doesn't affect him. He says

the only thing I did was Yesterday. He knows that's wrong. He knows and I know it's not true."

Even John himself seemed to regret it later on, suggesting he acted and recorded out of anger in the spur of the moment. "It's not about Paul, it's about me," he said. "I'm really attacking myself. But I regret the association, well, what's to regret? He lived through it. The only thing that matters is how he and I feel about these things and not what the writer or commentator thinks about it. Him and me are okay."

There's more rocking defiance on I Don't Wanna Be A Soldier, but again, we are shown his more vulnerable and tender side on the truly wonderful Oh My Love, with its sweet melodies and floating piano/guitar interplay. George Harrison colours it in with some gently considered work, while Lennon and Nicky Hopkins' pianos combine to make beautiful sounds. How? is another memorable tune with some thoughtful lyrics above another fine arrangement. It all closes off with Oh Yoko!, a simple and direct love song from John to his woman.

Imagine is an album of purity and passion, much more listenable and indeed enjoyable than its predecessor and also one of the best albums of the 1970s. The emotion is all there, only the bare boned sparseness of his debut is softened with some lovely musical flourishes; be it the guitar solos, the wonderful violins scattered tastefully throughout or the iconic Lennon piano style. It's melodically rich and even though many insist it was Paul who had the knack of a good tune, Lennon illustrates that when he really wanted to, he could expertly mix both forms of expression; the raw spontaneity of undiluted emotion and the beautifully melodic.

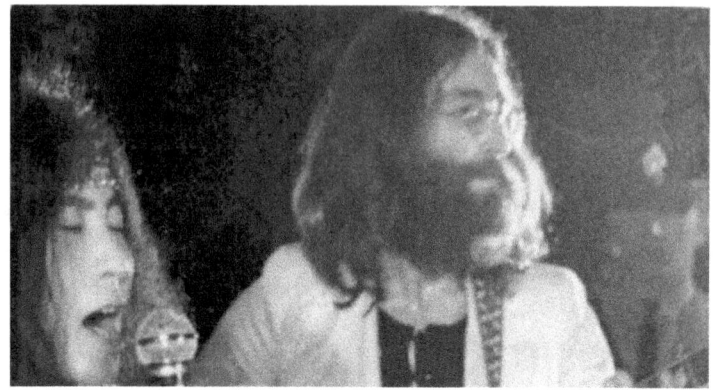

DAN RICHTER
TALKS JOHN AND YOKO

Mime artist and actor Dan Richter worked as John and Yoko's assistant from 1969 to 1974. Here he shares his memories of living with them at their home Tittenhurst Park.

Do you remember first meeting John?

We had an apartment beside Yoko's at Hanover Gate by Regents Park and Yoko was a friend. She brought John by for tea one day so we could meet.

You worked on Kubrick's landmark 2001 A Space Odyssey. How did you go from this to being John and Yoko's assistant?

I was between jobs and my wife Jill, our baby Sacha and I had just come back from a trip in the States and needed a place to stay. John

and Yoko invited us to come out and stay with them. While there we got talking and they asked me to help out on their film and recording projects as well as help with the renovation of their new estate Tittenhurst Park. I lent them a hand and one thing led to another and I ended up working for them.

You were around in John and Yoko's heroin period. What was this time like?

Heroin was widely used that time in London and for a while we all were using, though John and Yoko never had a serious problem with it and stopped using after experimenting with it.

The music he was doing back then was some of his finest work. Did you get up close access to his craft? What was it like to see him writing classic material?

I worked closely with John as with Yoko and was lucky enough to watch his and her work processes, as well as managing much of the recordings. John was a unique genius and it was magical to be around him as he created so many iconic works.

You saw to the photography of the Imagine video film. What was it like making it?

Imagine was a lot of fun. John and Yoko were having a blast dressing up and shooting all the different scenes. With John's quirky sense of humour and Yoko's great ideas the whole project was

wonderful to work on. At the time we thought of it more as a film than another music video.

What was a typical day like living with them?

Read the mail, check how the day's schedule was going. Meet with them in the morning to discuss plans for the day. A lot of ideas, dreams and laughter.

Do you have any favourite John Lennon songs?

God, Imagine and Jealous Guy

Any special memories of John of this time?

Not anything special, just the fun we had. Our days were filled with creativity and laughter even when being involved in very serious issues. I loved his shyness and vulnerability. He was the real thing.

Why did you end up moving on and moving out?

When they decided to stop working on the film projects and reduce the recording work I wanted to stay busy so I returned to my work as a mime and film performer.

When was the last time you saw him?

It was during the year he was with May Pang. We met amount a gaggle of attorneys where I helped them review a bunch of work documents. John and I slipped off for a few minutes together in an empty office to catch up. I never saw him again after that. I was up at the Dakota a few times but missed him.

How do you look back on Lennon as a man and artist?

John, like many great geniuses, was completely his own man. He was always completely genuine and honest. He saw everything with new eyes and I think his great gifts were sometimes a heavy load for him to carry. What I remember most was that he was a good friend that I had a lot of fun with while I had the privilege of witnessing him create some of the most important music of the 20th century.

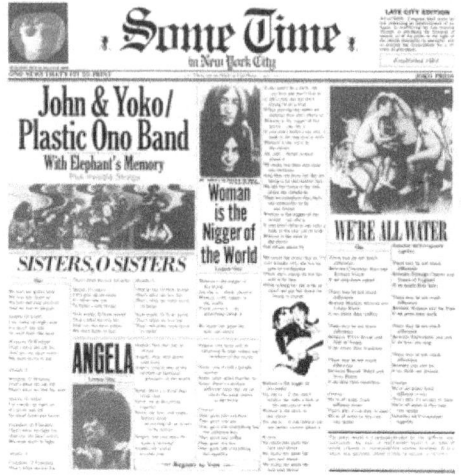

SOME TIME IN NEW YORK CITY

By 1971, Lennon was becoming more of an alternative figure than a mainstream one, having gotten involved with New York political issues with Yoko that resulted in his reputation as a counter culture icon. Now living permanently in the Big Apple as of August that year, he recorded the seminal Christmas classic Happy Xmas (War Is over), possibly the most beautiful seasonal song ever released in the charts. (Paul's Wonderful Christmas Time was good fun, but Lennon's is a stand alone gem all year round.) By 72 though, the American Government were keeping a close watch on him, seeing his activities with such left wing activists as Jerry Rubin as troubling. Certainly, before meeting Yoko, John never seemed to be an overly political animal, but in the new decade it was clear that he was keen on getting involved in any cause that came along which he felt

passionate about. In turn, the radicals and Lefties took advantage, trying their hardest to get him on board their causes for publicity.

Although perfect it may not be, the album he made in the midst of this activity, Some Time in New York City, is a brave and vastly under rated affair. Heavily political and at times very near the knuckle, it was clear by then that the knives were out for John and Yoko once again. Not that they eased the situation by the controversial material they were recording. Some Time in New York City was well and truly hated upon its release and with hindsight you can perhaps see why it caused so many ripples. Featuring a whole side of live jams with Frank Zappa and the Mothers of Invention from a 1971 concert at Fillmore East, elsewhere there were such pressing numbers as Woman is the Nigger of the World and protest songs like John Sinclair, while individual lines about Charles Manson and the Pope being similar were bound to offend. Still, the album may be ragged and rough around the edges in its style and production, but it's a brilliantly realised concept and full of thought provoking imagery and ideas.

Highlights of the double set include a live version of his single Cold Turkey, recorded in December 1969 at the London Lyceum ("This song's about pain!") and Yoko's Born in a Prison, which is dead on with its condemnation of society's structural flaws. Often bleak, always interesting, this is much more challenging than Imagine, and maybe just as interesting on a musical and lyrical level too.

For Lennon, in some ways at least, the record was a love letter to his new hometown. In the famous Rolling Stone interview with Jann Wenner, Lennon was vocal about his adoration of the city. "America is where it's at. You know, I should have been born in New York,

man," Lennon said. "I should have been born in the Village! That's where I belong! Why wasn't I born there? Like Paris was in the eighteenth century or whatever it was, London I don't think has ever been it. It might have been literary-wise when Wilde and Shaw and all them were there. New York was *it!* I regret *profoundly* not being *American* and not being born in Greenwich Village. That's where I should have been. But it never works that way. Everybody heads towards the centre, that's why I'm here now. I'm here just to breathe it. It might be dying, or there might be a lot of dirt in the air, but this is where it's happening."

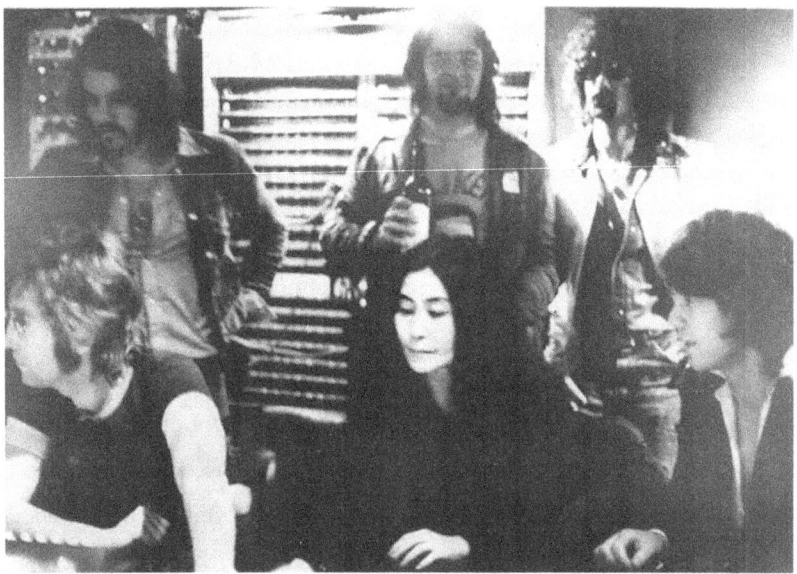

The backing band Lennon used on the album do deserve their fair share of credit for making the whole thing such an exciting musical journey on the fringes of legality. Despite their classic tracks on the soundtrack to the 1969 film Midnight Cowboy, Elephants Memory will always be remembered most for their association with John

Lennon and The Plastic Ono Band. As well as playing on this record, they also backed him for various concerts. A live document of their 1972 New York show is commercially available and shows the group playing beautifully together, with Lennon on brilliant yet unfortunately rare in-concert form. (Why oh why didn't he tour?) While working with Lennon may have been fantastic, it has kind of been the reason Elephants Memory have not become widely known for their own music. As someone said, they have become "a side note to Lennon."

The band's bassist, Gary Van Scyoc told me a little bit about how he joined Elephants Memory and those days spent with Lennon:

"I joined the band in late 1970 after leaving my band on Columbia Records called Pig Iron. John and Yoko came down to our rehearsal studio one night in Greenwich Village called Magnagraphics. He had heard a tape of a live radio broadcast that we had recently done on WLIR Long Island NY. John was given the tape by our mutual friend at the time, activist Jerry Rubin. We jammed on all John's favourite old rock and roll songs till our fingers were sore and John started talking about how he missed playing in a band, how hard it was to get the then Plastic Ono band members together as they were jet setting around with their own projects. So he wanted to join Elephants Memory. We finally agreed to call the merger the Plastic Ono Elephants Memory Band. Yoko quickly came up with P.O.E.M. That was the beginning of a very intense two years of playing and recording. John produced our Elephants Memory LP on Apple in 1972. John picked my song Wind Ridge as the most likely single and wrote some beautiful piano lines for the tune but wouldn't take any writing credits for his contribution. John and I got along

tremendously well and Yoko said it was because we were both number "9's" in her numerology studies. We played Madison Square Garden in the summer of 72 as well as many of the day's top TV shows. We did Yoko's Approximately Infinite Universe in 73 which is a double LP. Also quite a few singles for her. Woman is the Nigger of the World was the single from the Some Time in NYC LP."

Most people will remember Some Time in New York City for its clever sleeve. Just like Jethro Tull's prog rock classic Thick As A Brick from the same time, it presented itself in the form of a newspaper, with headlines and stories on the gatefold sleeve. Lennon's was much more proto-punk-rock though, and lacked the very British humour on Tull's sleeve. "You see how they banned the picture here," John spat in 1980, still peeved by the album's poor treatment. "Yoko made this beautiful poster: Chairman Mao and Richard Nixon dancing naked together, you see? And the stupid retailers stuck a gold sticker over it that you can't even steam off. So you see the kind of pressure Yoko and I were getting, not only on a personal level, and the public level, and the court case, and the fucking government, and this, that, and the other, but every time we tried to *express* ourselves, they would ban it, would cover it up, would censor it."

Cast yourself back to 1972 and rock had become a kind of dismal place. Reality was gone from this art form, and the kind of raw intensity Lennon put in his music was fading from the mainstream. This was the age of new Heavy Metal, of Led Zeppelin posturing, and shallow glam rock, a genre Lennon himself dubbed "rock and roll with lipstick" rather correctly. Worse still, no one was being political anymore. Even Dylan, at one point the leading force in the

movement of addressing social injustice and crooked hypocrisy, was out of view completely by 1973. He wasn't to properly return as a key force in the rock world for at least two more years, with Planet Waves respectably, then Blood on the Tracks in 1975. Lennon, an uppity Brit and one time Beatle, was the only man who dared to speak out about controversial subject matter. The rag tag and rocking musicality pre dated punk by half a decade, and Lennon clearly had something to say, more than ever before in fact. However, they just didn't want to hear it, and the record was torn to shreds by the critics.

Rolling Stone famously dismissed the LP, writing, "Throughout their artistic careers, separately and together, the Lennons have been committed avant-gardists. Such commitment takes guts. It takes even more guts when you've made it so big that you don't need to take chances to stay on top: the Lennons should be commended for their daring. What is deplorable, however, is the egotistical laziness (and the sycophantic milieu in which it thrives) that allows artists of such proven stature, who claim to identify with the 'working class hero', to think they can patronise all whom they would call sisters and brothers."

"It almost ruined it," John said of the effects the critical hammerings had on his song writing confidence. "It became journalism and not poetry. And I basically feel that I'm a poet. Then I began to take it seriously on another level, saying, 'Well, I am reflecting what is going on, right?'"

The album didn't make the Top 40 in the US, a country Lennon had totally dominated only a few years earlier in the Fab Four. Over time, its appeal would grow, but it is still the bastard son of Lennon and Ono's rich, but all too brief, discography together.

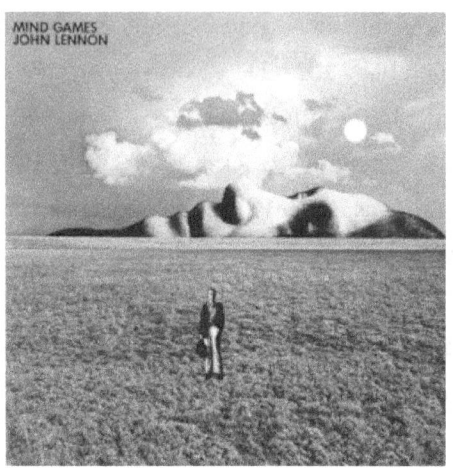

MIND GAMES

Lennon's solo discography is a varied and often dangerous place to visit upon. You have light and dark, anger and tenderness, risk and safety. It's a catalogue of contrasting moods. With Plastic Ono Band, Imagine and Some Time in New York City done in a three year space, Lennon's career becomes a little less focused from here on - at least in comparison to that classic trilogy - although there are gems all the way through the journey.

There is a sense of danger on a record like Some Time In New York City entirely lacking on John's follow up record. Indeed, Lennon returned to more grounded territory on 1973's Mind Games, a nice LP on the whole. "When this came out, in the early '70s," Lennon told David Sheff, "everybody was starting to say the '60s was a joke, it didn't mean anything, those love-and-peaceniks were idiots. 'We all have to face the reality of being nasty human beings who are born evil and everything's gonna be lousy and rotten so boo-hoo-hoo.' 'We

had fun in the '60ss,' they said, 'but the others took it away from us and spoiled it all for us.' And I was trying to say, 'No, just keep doin' it.'"

Lennon was distancing himself from the dangerous, edgy political subject matter of Some Time in New York City for quite obvious and sensible reasons. Wishing to become a US citizen, controversy was now something he was wishing to avoid at all costs, at least as much as he could help it. The FBI were on his tail, hassling him at all times. Not giving them precisely what they wanted, Lennon calmed himself down, furthering his name from left field, far out causes, and made an approachable album, his most commercially accessible yet.

Any album featuring such key classics as the opening title track, a haunting song in itself with some wonderful musical backing (all sliding guitars and marching drums), is bound to be a winner. Perhaps knowing he was cooking up quite a bit of heat in America with his more political material (and indeed making it difficult for himself to be properly accepted by the government), Lennon became safe. Again though, it all came down to the simplicity of love, the thing he once said was all you needed.

There was a little bit of anger still there though, especially on Bring on the Lucie (Freda Peeple), a wonderful song which makes you want to wave your fist in the air at the powers that be. There's some boogie-woogie shenanigans on the likes of Tight A$, and it's clear that John still loved that dear old rock and roll of his.

Aisumasen is a slow bluesy number, that in its stripped piano, drums and bass arrangement could have seen it fit on to the Plastic Ono Band LP. There is a ghostly quality to this, and the jagged chord changes are unsettling. Again, it's that voice which stuns the most,

pure and spiritual from start to finish. If this was an apology to Yoko, it was a sincere one and must have tugged at Ono's heart. "All I know is just what you tell me" is one of Lennon's most superb lines.

One Day (At A Time) is a soft love song with sliding guitars and beautiful backing vocals. The chorus is similar to his own #9 Dream, but there is more of a 60s girl group vibe to it. Though backed by female voices, Lennon's tones are the most feminine of all. Indeed, this is his least "manly" vocal, revealing his vulnerabilities to us all.

Nutopian International Anthem is four seconds of silence, this being a reference to the imaginary country Lennon invented during his difficulties becoming a US citizen. "We announce the birth of a conceptual country, NUTOPIA," Lennon announced on April Fool's Day in 1973. "Citizenship of the country can be obtained by declaration of your awareness of NUTOPIA. NUTOPIA has no land, no boundaries, no passports, only people. NUTOPIA has no laws other than cosmic. All people of NUTOPIA are ambassadors of the country. As two ambassadors of NUTOPIA, we ask for diplomatic immunity and recognition in the United Nations of our country and its people." Obviously such a country, devoid of discrimination, doesn't need its own anthem. It's a world, like the one he sang of in Imagine, that can never exist.

Intuition is a brilliant upbeat rocker with some great bouncing bass and drums, not to mention the surreal bubbling keyboards. John is a master of melody here, as he is on Out the Blue, a more simplistic number that would have slotted nicely on to Imagine. There's a gentle melancholia, and the acoustic plucking that opens the song reminds one of the White Album.

I Know (I Know) is a personal favourite of mine, featuring a great melody and some strong vocals. It's also one of his most open songs, again where he admits his insecurities and flaws. You Are Here, its title taken from a 60s Lennon exhibition, is plain beauty personified. Musically, it's possibly the finest song on the album.

Meat City is a chunky rocker with some mean power chord riffing and licks, not to mention a trippy Lennon vocal. In many ways it's a trip back to the psychedelic sixties, even featuring a groovy backwards refrain of "Fuck a pig!" It ends the album on a high note of wailing guitars and stomping drums.

Despite the treasures on it, Mind Games was panned at the time, with Rolling Stone calling it his worst album yet. Over 40 years on though, it sounds fresh, and while not as strong as the three albums before it, it's still good material, no doubt about it.

"The album's music might have served as the basis for a good LP if it had been paired with some new lyrical insight and passion," spat Rolling Stone. "But instead, Lennon has come up with his worst writing yet. With lines like, "A million heads are better than one/So come on, get it on," a listener can only accept or reject them. I've done the latter. Mind Games reveals another major artist of the Sixties lost in the changing social and musical environment of the Seventies, helplessly trying to impose his own gargantuan ego upon an audience that has already absorbed his insights and is now waiting hopefully for him to chart a new course."

After the album's release, Yoko and John parted ways. By then their relationship was showing strain, and Yoko had been hurt by John having sex with another woman at a party. In this period, Lennon drifted into heavy drinking with his new pal, the wild Harry Nilsson,

and entered a romantic relationship, upon Yoko's strong suggestion, with May Pang. This was the much documented "lost weekend," where a clearly out of control Lennon spent most of his time partying with friends in New York and Los Angeles. Phoning Yoko drunk on several occasions, pleading for her to take him back, he was turned down until the time was right. Yoko clearly valued what they once had and would do anything to get John back the way she knew and loved him.

"He wrote what he was feeling at the time," May Pang later said of the record. "It's all about him, going through a transition at the time. He talked about the Mind Games cover, when he created it. Yoko is the mountain and he's walking... and in one of the pictures, he walks further away. He said to me, I guess unconsciously I knew I was walking away. And I had no idea. It was great fun doing the album, because for the first time he was working with real top session musicians. This was the first time he worked with a whole New York crew, and he loved it. He loved the professionalism of it. He loved hearing all the stories from the musicians, and he loved hanging out."

Whichever way you look at it, this is definitely a vibrant, energetic album with Lennon on fine form throughout. Though it heralded a difficult era in his life, the record preserved a moment in time, a transitional phase which saw Lennon leaving the political madness of Some Time in New York City and heading further into himself. And not in a self indulgent, up-his-own-arse way - in a relatable fashion that made him more of a flawed, relatable hero to his army of followers. A fine record which seems to get better as time goes by.

AN INTERVIEW WITH RICK MAROTTA

Rick drummed on a couple of tracks on Lennon's 1973 LP, Mind Games. Here he shares his memories of John.

Do you remember when you first heard you'd be working with John?

I think I got a call from Dave Spinoza telling me that they wanted me to do some sessions with John. I had also been working with Yoko at the time so I think John wanted to have that band too. It was also interesting for me because we were going to do some double drum stuff with Jim Keltner and I always loved his playing.

What about your first meeting with him? Do you recall what happened?

The first meeting with John was pretty funny. I walked into the studio a little early to get myself situated and set up comfortably. John was sitting at the console talking to Jack Douglas who I knew very well. I was wearing an S.I.R. Instrument Rental tee shirt so when I walked in the room John turned to me and said I could just leave the gear in the studio. Jack said "This is Rick Marotta" and John immediately jumped up and apologized for not recognizing me. He couldn't be more unassuming.

What did you think of the new songs you were playing on?

I didn't really think anything. I did sessions everyday back then so to me they were just new songs to do. Only difference was that they were John Lennon songs so I felt that was special. I definitely paid attention.

What were John's instructions to you for the record? Did he have specific ideas in mind for you?

I don't remember but I don't think he had any instructions. He would play the song, we'd come up with a part and start playing.

What was John like in the studio? Other musicians from this time say he was very down to earth and relaxed with the band.

I didn't spend that much time in the studio with him. He was very relaxed. Treated the band like a band. He was very respectful of everyone on the sessions. (He didn't use amateurs.) To me, it was a lot

like playing in someone's basement... only it was John Lennon's basement.

Do you have any stand out memories of John Lennon?

My memories of John were probably the same as everyone else. He was a really nice guy, down to earth, normal, didn't like a lot of fuss around him so we just all acted totally normal. I remember going to dinner with him a few times outside of the studio and that was difficult because he was John Lennon. People made a huge fuss. He was used to it, but you could tell he wasn't happy about it.

One stand out memory for me was when I was playing at the No-Nukes Concert at Madison Square Garden. I had just come off stage and there were John and Yoko. They came over to talk to me and tell me that they were enjoying the show. All of a sudden, this little weirdo came running over. He was wearing a blazer with a path on it of his head, shaped like a light bulb. Above the light bulb it said, "I'm a Fuckin' Genius." He jumped in front of me coming up to about my navel and started spewing. "Who the Fuck are you? I'm a Fuckin' Genius. Do you know who I am?" etc. John jumped in and grabbed him and started laughing saying "Calm down, this is Rick Marotta, He's working on my record and he's working on Yokos record." John was holding him as though to pull him away and they started laughing. John then apologized again and said that the guy was a total nut case. The Nut Case Was Phil Spector. He really was crazy.

WALLS AND BRIDGES

"The work of a semi-sick craftsman"
- John Lennon, 1980

One of Lennon's most legendary records, and not just for musical reasons, was 1974's Walls and Bridges. With a cover taken from John's old schoolboy doodlings, it was written and recorded during his 18 month break from life with Yoko. This was the "lost weekend" of myth, where Lennon was out with Harry Nilsson getting wild, and dating May Pang. His life had transformed beyond belief, and the album reflects Lennon as a changed, and often troubled man. The inner sleeve notes were just as interesting as the record itself, with more drawings, lyrics and even a reference to his infamous UFO sighting.

Musically, this is almost an extension on Mind Games, haunted by the ghost of his and Yoko's love, soon to be reincarnated in very little time. Song wise, there are similarities to Imagine, but Walls and Bridges also has its own place in the Lennon discography. It opens with Going Down On Love, with Lennon as a down-but-not-out love warrior, wounded by his romance. There is a contradictory factor to such songs, where John seems to be celebrating his so called freedom, but also longing for his truest soul mate, It's a dichotomy John found himself in, and he was able to channel those thoughts and feelings into fine art. Surprisingly, given his obvious emotional conflicts at the time, this is not a distressing Lennon LP, like say, Plastic Ono Band. It's actually a rather bouncy collection of songs, signified best in his classic duet with Elton John, Whatever Gets You Thru the Night, easily one of his finest solo cuts. Sleazy sax and Reg Dwight harmonies punctuate this US Number One hit.

Old Dirt Road is a stand out, his co-write with the great Harry Nilsson, and the funk factor is turned to 11 for the seedy delights of What You Got. The bongo fury on this song, and indeed much of the album, is what separates it from his other work, and the instrumentation is perhaps the richest here than it ever was on another John LP.

Bless You is simply gorgeous, again, smooth bongos giving it a bit of soul. The keyboards and guitars dance wonderfully, and again Lennon comes out front with a superb vocal take. Undoubtedly the finest song here is the startling and incredibly moving #Dream. In his final interview to the BBC, John would dismiss the song when he said, "That's what I call craftsmanship writing, meaning, you know, I just churned that out. I'm not putting it down, it's just what it is, but I

just sat down and wrote it, you know, with no real inspiration, based on a dream I'd had."

Despite the author's so-so attitude to the track, it's absolutely brilliant, with the double track echo laden vocal sending shivers up the spine. The strings, originally intended for a Nilsson song, are very emotional and the strange refrain that sounds awfully similar to George Harrison's My Sweet Lord always brings a smile to the face. Some of the music is utterly psychedelic too, rather like the delights of Sgt. Pepper and Magical Mystery Tour. May Pang insisted it was one of John's personal favourites, despite his later rubbishing of it. By the time of the BBC interview in 1980 though, he was back with Yoko, and perhaps such a song would only bring back the painful truth of the days when they were parted. Either way, this is a timeless song.

Among the other stand outs is Nobody Loves You When You're Down And Out, which is classic down beat Lennon gold. Like a bastard son from the White Album, the song is enhanced by a rich arrangement, with strings and excellent production. This one builds and sores, becoming more powerful as it goes along. The Phil Spector influence clearly rubbed off though, as it brings to mind the finest work of that rather curious diminutive killer.

Walls and Bridges is a great record, full of varying moods, rich music accompaniment and a soulful, human flame burning within. It wasn't exactly hailed as a Sgt Pepper for the 1970s (that was left for Wings' Band on the Run LP), but reviews were good, as were the sales. "This is a truly superb album by any standards," wrote the Melody Maker, "words and music a joy to hear, by a musician who has a rare talent for selling love without making you cringe."

RON APREA
ON LENNON'S WALLS AND BRIDGES

Ron Aprea played on Lennon's classic Walls and Bridges album. Here he shares his vivid memories.

You must have been stunned you were recording with John Lennon. Were you nervous at all?

There's always a certain amount of nervousness when performing. When you add a five horn recording session with no arrangements , a genre that is not in my area of expertise (I was a jazz musician touring with Lionel Hampton prior to this session),

musicians that I had never worked with prior to this session, with the exception of Steve Madai... what could go wrong?

Do you recall the moment you first met him?

Yes, I do. I arrived a bit early and it was just Steve, John, May (Pang) and me. Steve introduced me to John, and John smiled and welcomed me to the project. He briefly explained what his plan was (with the horns) and said something like, "We're gonna have some fun." Being a photography buff, I had my Kodak with me, and May took a picture of the three of us.

It's a great album, was it fun recording those songs?

Yes, it IS a great album, and was remarkable because Whatever Gets You Thru the Night was Lennon's only solo number 1 single in the United States during his lifetime. Was it fun? There are two answers to that question. The first triple session (9 hours) was not fun at all. Recording 5 horns without arrangements was not fun, and was a first for me. Steve (Madaio) had done "head" arrangements with Stevie Wonder and the Rolling Stones, and was quite comfortable with this setup. He assured me that it would get easier as we went along... and it did. John had a calming effect, as well...a sweet man, and very easy to work with. So, to answer your question, it was a blast after the first six hours.

The story of John photocopying his face is brilliant. You have that photocopy framed on your wall now. Do you ever look at it and pinch yourself, that you were working so closely with him?

John sticking his face in the copying machine (twice) is a moment that I will never forget. I didn't think it was possible to do that without going blind. It seemed to be a thought-out plan, and I felt that this was his way of giving a gift to a couple of friends. After risking his eyesight, he took the two Photostats, handed one to Steve and one to me and said, "Hang on to this, some day it will be worth a lot of money." He smiled and exited the room.

I've been fortunate to have worked with many great artists whom I idolized as a kid. And it's always a big kick. I toured with Woody Herman's band in 1968 and Lionel Hampton's band from 1969 thru 1973, and did some recording with Hamp's band and others as well. We also did a few TV shows and a concert at the Smithsonian Institute in Washington DC, where my solos with Hamp were recorded and put into their archives. And while on tour I actually got to play with Louis "Satchmo" Armstrong one evening. Those experiences, and others, were invaluable, and prepared me for the John Lennon project. And YES...it was a big moment in my career, and I was well aware of how big it was.

What are your favourite Lennon tracks?

It's hard to pick a favourite. I love them all, but on several occasions I've been invited to perform at the Return To Bangladesh concerts, and last year I was invited to play at the Chicago Beatlefest. They always ask me to play Whatever Gets You Thru the Night. John had a big hit with that song. The audiences love it, and I love playing the Bobby Keys solo.

You've spoken how down to earth he was. Is it refreshing in the business to work with someone so famous who is also so humble like that?

Thanks for asking that question. John spent his life working with only a handful of musicians, so most of us only knew what we heard on the news or read in the newspapers. And much of it was negative. It was indeed refreshing to discover that John was a sweet, sensitive, and humble man, and though this may shock the world, the only "addiction" of John's that I saw was to salads and fruit drinks.

Those walks home with John from the studio must have been truly amazing. What are some of the things you spoke about together?

The things we spoke about during those mid-summer middle-of-the-night walks through Manhattan mostly pertained to the project and a lot of small talk, but the thing that is vivid in my mind is how he enjoyed chatting with everybody. Waving to truck drivers and kneeling down to say hello to a homeless person. I admired his

friendliness and empathy, but I didn't understand his lack of fear... the most famous person on the planet walking unprotected through the streets of New York City? As a native New Yorker, I was worried for him.

Do you remember where you were and how you felt when you heard he had died?

I was at home watching TV when I heard the news. I cried like everyone else, said a prayer, and thought... damn it, I was right.

How do you look back on the time spent with John?

Glorious. I wish we could do it again.

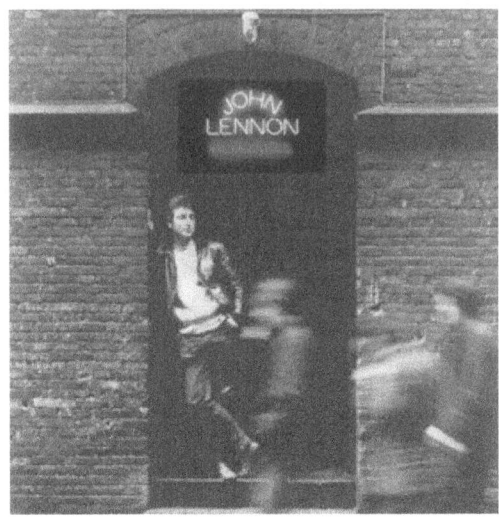

ROCK N' ROLL

John had made a run of classic records, some of which were not instantly embraced, but in time would be roundly regarded as key works of ex Beatles in the 1970s. But Rock n' Roll, released in 1975, was something of a disaster, being produced by the afore mentioned little rascal Phil Spector, when all concerned were at their most hedonistic and obnoxious. The messy production schedules and wild nights are very evident in the results, and the album features very few genuinely inspired moments. Not that it isn't enjoyable of course, because it really is (let's face it, a rock and roll covers album done by Lennon was always going to be a good idea), but it lacks much of the power of his earlier solo records. That said, there are some great renditions, like his moody take on Be Bop A Lula (which could have done with less echo) and Stand by Me, a remarkable cover and

probably the finest version of the song ever recorded. His vocal efforts here are passionate, sending shivers up the spine as he had on the best Beatles work.

Gary Mallaber, who drummed on some of the Rock n' Roll sessions led by Phil Spector and co, told me all about the making of the record:

"Late 60's, early 70's, while recording with Van Morrison in New York, then after his move to the west coast in San Francisco. I was beginning to be invited down to LA to record. I was recording with Jesse Ed Davis of Taj Mahal while he began to rehearse with George Harrison for The Bangladesh concerts. Several nights we all wound up at The Record Plant on 3rd avenue; myself, Jim Keltner, Jesse, Carl Radel and then showing up was Mick Jagger and John Lennon. This was during his troubled time with Yoko. Anyway, we recorded many different pieces on into the morning. Those tracks were kept and eventually used for whatever they became. It was a very wild time and no one was keeping track of anything, as far as I knew. So, I would not know how to re-trace that work. It was quite a time! It was a wonderful music time when songs were being recorded and produced every hour of everyday. But even though I had been doing spectacular work with Van Morrison, I still did not have a place setting with my name on it at the big dining room table."

A wild time indeed. But the truth is that John had always wanted to record a straight rock and roll covers album. The actual genesis of this album however, came about in a very different manner. When Lennon cut Come Together with the Fabs back in 69, he directly lifted from Chuck Berry's You Can't Catch Me. Morris Levy, the song publisher who saw to Berry's work, threatened to sue John for

copyright theft. The case actually went to court, and the settlement was that Lennon had to record at least three Levy owned songs. While forced to cut them, Lennon decided to go the whole hog and get stuck in to doing a full LP.

Spector and Lennon made a dynamite team, and their regrouping led to every musician in LA wanting to jump on board this crazy ship. It might have been good fun, but by no means is this among Lennon's finest work. His eventual cover of You Can't Catch Me is ruined by an awfully strained vocal and too much stuff going on musically, but there are other hidden gems here. Do You Want to Dance is cool, with those infectious bongos at the forefront. Lennon's vocals though are buried in the mix, as they are on much of the LP, and he never sounded so weak and lacking in passion as he does here.

The rolling thunder of Peggy Sue is admittedly brilliant, with that classic Spector sound bringing this update to life. Lennon's vocals are low key, but pay a fitting tribute to the lord of rock n' roll himself, Buddy Holly. Songs like Ya Ya are totally throwaway, and Just Because brings to mind the bloated, over produced nightmare that was Spector and Leonard Cohen's vile Death of a Ladies Man. Despite some of the horrors, there is definite fun to be had; you just have to take it on its own terms and ignore the marvellous masterpieces that preceded it.

"It started in '73 with Phil and fell apart," Lennon told Rolling Stone in 1975. "I ended up as part of mad, drunk scenes in Los Angeles and I finally finished it off on me own. And there was still problems with it up to the minute it came out. I can't begin to say, it's just barmy, there's a jinx on that album."

One of the main problems with the album - and let's face it, there are a few - is Lennon's voice. As on the closing song, he is often painfully out of tune and rasping; and not rasping in a good way, as on the end of Twist and Shout. Compared to that, this is just painful, sounding closer to tone deaf Lou Reed circa the late 70s, yet without the charm. Instruments seem to battle for centre stage in the dreadful, muddled mix and the whole thing is actually hard on the ears. There is the odd moment of gold, like hearing John signing off as Winston O Boogie at the end, but it is definitely his worst solo LP. While he'd nailed rock and roll standards in the Fabs, on Rock n' Roll he drags them kicking and screaming into the sleazy seventies. If it doesn't quite cast you back to the early 60s in Hamburg, it is at least like spending an evening with a drunken John Lennon, telling you about those old hedonistic days. And that, in itself, could never be all that bad. Still, worth buying for Stand By Me alone.

"On the back cover of the beautiful package, Lennon's name appears in lights — just like Chuck Berry promised they would in the last verse of Johnny B. Goode," wrote Rolling Stone, in one of their most astute reviews of a Lennon work. "At the bottom, there's the now famous quote (the best thing about the album, really) from Dr. Winston O'Boogie: You Should Have Been There. John Lennon *was*, but sounds like he's forgotten what it was like. In making an album about his past, he has wound up sounding like a man without a past. If I didn't know better, I would have guessed that this was the work of just another talented rocker who's stumbled onto a mysterious body of great American music that he truly loves but doesn't really understand. There was a time when he did."

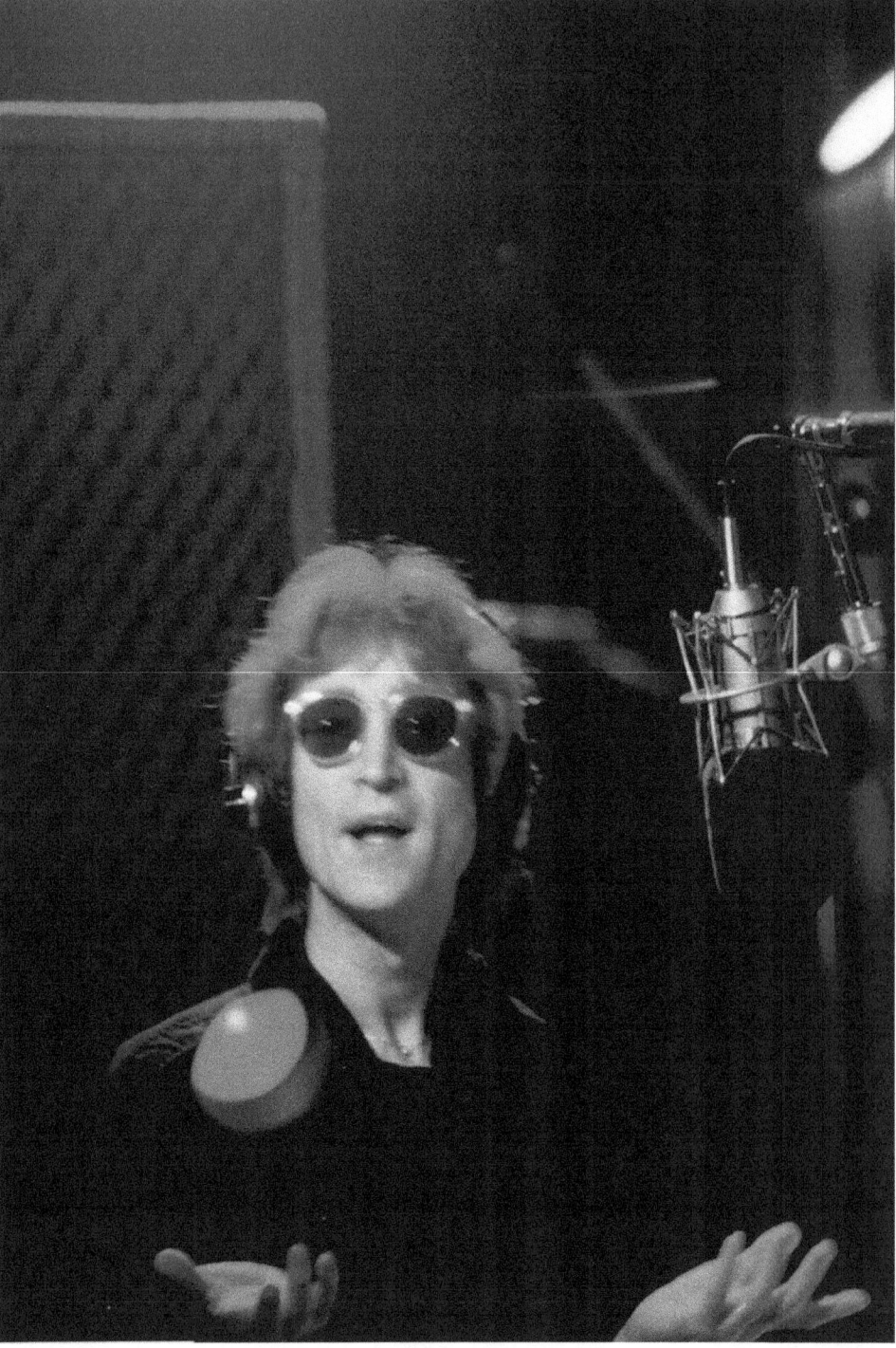

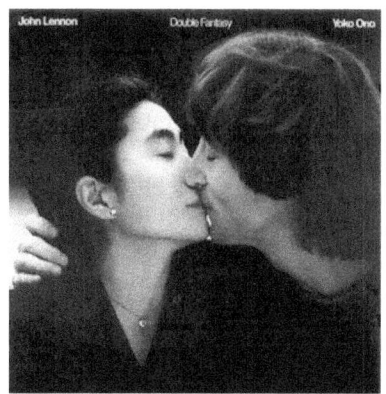 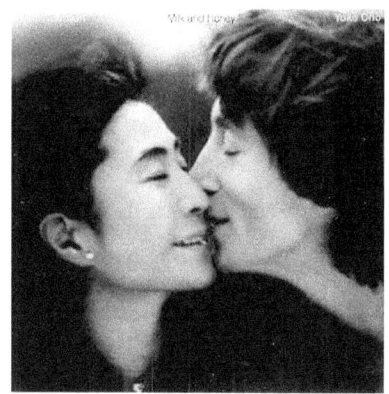

DOUBLE FANTASY & MILK AND HONEY

Much had changed between Rock n' Roll and Double Fantasy, and the personal goings on in John's life in this era would warrant a whole book to themselves. But as this book is about his records, one must skim through. Playing the house husband had been hell for John back in sixties London with Cynthia and Julian, but now in the confines of the Dakota building, back with Yoko, he seemed to really enjoy it. Music was something from his past now, and his son Sean was his new main priority. As if to prove this, Yoko even saw to business matters for him. John was busy playing with his beloved boy, taking him out, putting him to bed, as well as reading books and making bread. When McCartney turned up at the Dakota for a jam one day, Lennon happily let him in and jammed along. When Macca came along the next day though, a fuming Lennon told him, in effect, to piss off. This wasn't the early sixties anymore, and John

couldn't just drop everything. He was a committed father now, the kind of father he really should have been to Julian back in the sixties. But that was then, and this was now. As it stood, Lennon embraced his role as stay at home daddy.

However, one day in 1980, John heard Paul McCartney's Coming Up, which he hated to admit, was really good. Although Paul and John had not seen each other much through the 1970s, and at times their relationship had turned sour, they had started talking regularly on the phone. It took Paul to do something that John believed was genuinely good to get him off his arse and writing music again. And so he did.

As much as he loved his domestic home life, John was itching to create again. As he told David Sheff in 1980, "There *is* great satisfaction. I took a Polaroid of my first loaf. I was overjoyed! I was *that* excited by it. I couldn't believe it! It was like an album coming out of the oven. The instantness of it was great... But then it was beginning to wear me out, you see. I thought, What *is* this? Screw this for a lark. I'd made two loaves on Friday and they'd be gone by Saturday afternoon. The thrill was wearing off and it became the routine again. So the joy is still there when I see Sean. He didn't come out of my belly but, *by God*, I made his bones, because I've attended to every meal, and to how he sleeps, and to the fact that he swims like a fish."

Released shortly before his death, 1980's Double Fantasy didn't quite impress fans and critics as much as his earlier albums had done, but there were still some interesting tunes on it. But let's face it, the very fact he was recording again at all was something to get

excited about and with a bit of luck there was bound to be a lot more gold to follow for a long time. Of course, tragically, this wasn't to be.

Personally I think Double Fantasy is classic Lennon. The opener Just Like Starting Over is an optimistic song of hope which signalled the potential for a new age in John's life as a musician, husband and father. The music is light and breezy, Lennon at times aping his idol Elvis in a playful manner. If he'd adopted this kind of approach for his Rock n' Roll album, it would have sounded like a genuine tribute to the genre, rather than a drunken shambolic raise of the glass. Here though, he was more focused and together, thanks in part to Jack Douglas who was acting as producer alongside John and Yoko. It's a beautiful song, and really makes one think of life's possibilities which may, or in this case may not, wait ahead for you.

"All through the taping of Starting Over, I was calling what I was doing Elvis Orbison," John later remarked. "It's like Dylan doing Nashville Skyline, except I don't have any Nashville, being from Liverpool. So I go back to the records I know - Elvis and Roy Orbison and Gene Vincent and Jerry Lee Lewis."

Elsewhere there was undeniable beauty such as Woman, his true ode to Yoko, a song which immediately elevated itself into the heavens reserved for classic Lennon material. Simplistic melodies, beautiful music, smooth guitars and beautiful words; it's the formula for many a Lennon masterpiece that seems to come directly from his damaged, but now repairing soul.

There's the song for his son, Beautiful Boy (Darling Boy), which undeniably comes across as the ultimate father-son love song. It's slightly schmaltzy yes, but just on the right side of sentimental brilliance. The Japanese tinged arrangement cascades down like rain,

colouring in the acoustic strums and dazzling melodies. It's very moving, and I am not sure how Sean himself could ever get through a full listen of it without welling up.

John seemed to have a new lease of energy and passion for both music and his life, and Double Fantasy really sums this brief time up perfectly. Interviews from the time present a man on the brink of something great, someone who had been through the shit and come out the other end as a wounded but wiser man. Tragically, in one of the most horrific events of the 20th century, and only the month following the album's release, he was shot and killed outside his Dakota home. He died quickly on the way to the hospital. Yoko was devastated, as were millions of others all over the world. After all, we had lost one of the most charismatic, talented, passionate, daring, flawed, honest, well loved figures that had ever lived, not just of the music industry, but of the world as a whole. Of course, it turned John into even more of an iconic figure. I wasn't born, but my dad recalls walking up the stairs to his workplace on December 8th, hearing the news halfway up the steps and breaking down into tears.

The twin onslaught of Double Fantasy and his shocking murder weren't quite the end of the Lennon musical tale though. The posthumous Milk and Honey, released in 1984, is definitely a mixed bag, but it does have some nice tunes on it. And when you consider the infamous 1980 Yacht trip - when Lennon ended up alone at the head of the boat and terrified at sea - was the event that kick started his song writing into gear, he managed to get a lot done in that half year before his death. Yet one cannot help but wonder, what would he have done next?

Milk and Honey is not perfect, but you have to consider Yoko's obvious fragility at the time, and just how difficult it must have been to mix John's songs, hearing his voice once again from beyond the grave. Three years in the making, it eventually saw release in 1984 and was another world wide hit. The now classic Nobody Told Me eventually became one of Lennon's seminal solo tracks, a catchy hook with imaginative, rich lyrics in classic John style. There are sprinklings of gold throughout, so regardless of what you think about Yoko, you have to give her credit for finding the strength within to press on and finish the record, especially when you consider the emotional horror she must have still been feeling.

Although his solo career was brief, especially in comparison to Paul's, history has remembered him as the most credible Beatle. He was the one who spoke directly to our hearts, often regardless of conventional melody or arrangement, but also, somewhat contradictorily, often to the most beautiful back drops imaginable. He was a man who cared little of upsetting the apple cart. Although Paul has gone further musically with his sounds, John always had a firmer grip on the human soul, the simplicity of a direct lyric that spoke right to you - for the most part at least. Double Fantasy, and to a lesser extent Milk Honey, are his swan songs, a glorious final bow from one of the most important and iconic figures in history.

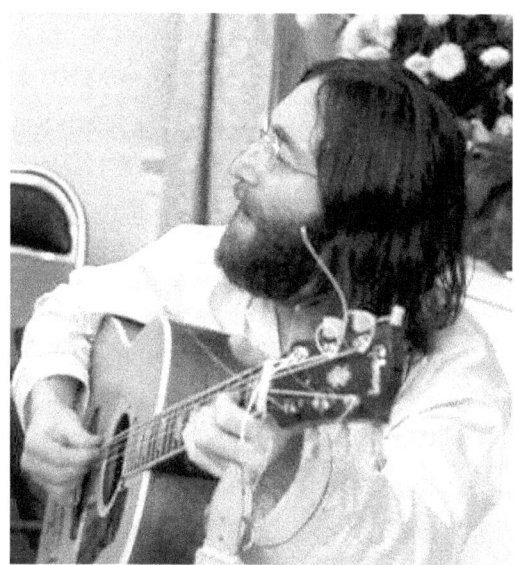

COMPILATIONS AND POSTHUMOUS COLLECTIONS

Most people reading this book will no doubt be aware of Lennon's most famous work, so the world of Lennon compilations may not be of interest to you. Indeed, there are a lot of Lennon compilations now, either hits packages, themed albums of various songs or soundtracks; perhaps too many in fact, and more than John himself would have cared to have in his name. Any true John fan though, no matter how cynical towards repackaging, needs to obtain a copy of Shaved Fish. Released firstly in 1975, it compiled all of John's solo hits up to that point, some of which had not been available on albums yet. Give Peace A Chance, Cold Turkey, Instant Karma, the mercurial Power to the People (a stonking Lennon anthem) and Happy Xmas

(War Is Over) were non album singles, so anyone who had worn out their 7 inch copies just had to purchase Shaved Fish. Like Paul's late 70s Wings compilation, it was an essential ex Beatle collection, and still is. That said, compilations like the CD of Lennon Legend are even better, for they include everything up to 75, and also everything single-wise that was released after, as well as some extra key tracks, like Working Class Hero for instance.

A very important posthumous release came in 1986, with Menlove Ave (251 of that street being Lennon's boyhood home in Liverpool), which was compiled from the Walls and Bridges and Rock n' Roll sessions. Worth it for the stunning Warhol cover alone, it features such solid cuts as Here We Go Again, an alternate take of Old Dirt Road and a wonderful version of Spector's To Know Her Is to Love Her. Not one of his best releases, but a valid set all the same.

In 1988. the film Imagine was released, a touching and ultimately essential video bio of John's life, with a glorious soundtrack album to go along with it. The tidy 21 track CD features key Beatles cuts used in the film, goes through his solo catalogue and ends on his anthemic hymn, Imagine itself. In many ways it's the ultimate Lennon compilation, for importantly it spans his whole 18 year recording career, Beatles and solo combined. In my view, assessing John as a recording artist is only complete when putting both his outlets side by side.

Even more essential is the 1986 release of his Live in New York City concert, recorded initially in 1972. Far better than the mixed and rather ragged Live Peace in Toronto 1969 album, this rocking set features back up from the Elephants Memory Band, with Yoko and the legendary Jim Keltner (a staple of many of John's albums) on

drums. There are terrifyingly good renditions of Come Together and Instant Karma, while one cannot help but be moved by the closing chorus of Give Peace a Chance.

Easily the best posthumous release is the lavish square boxed John Lennon Anthology, the crown jewels for all collectors of John's music. Conceived by Yoko, each of the discs was separated into representing key places and themes from John's life as a solo artist - Ascot, New York, his Lost Weekend and the Dakota building.

"I was more interested in making it into an event," Ono said to Elsewhere of the project, "and an artwork in the sense like John and I would do. Each CD would have a theme, a kind of total experience and each should be different from the other. Of course, some things didn't get in there. I don't have enough to make a strong statement like this again. I don't think there's going to be another box, but it may have to come out in a different way. In John's case he's not here any more so he can't promote his catalogue of songs. I'm just doing my best to keep his catalogue out there and for that you have to keep on creating familiarity through merchandise or whatever."

The set itself is utterly definitive, and I cannot imagine (again, a carefully chosen word) a Lennon fan being disappointed with the gold on offer here. While some whine that John is being merchandised and re-merchandised to a ludicrous degree now, it's undeniable that the rebranding and repackaging is keeping his legacy alive. Sure, John's music speaks for itself, and it would last forever in its own right, but Yoko has ensured he appeals to every new generation that comes along with her devotion to his art. With releases like this, the legend can only enhance over time. However, the 2004 Acoustic release, which brought together unplugged gems

and numerous tracks already put out on the anthology, was heavily criticised as cashing in on his myth. Still, it became his best selling posthumous record and contains gem after gem.

There have also been some rather pointless soundtracks and miscellaneous releases too, which don't really enhance the discography that much. The US Vs John Lennon was a fantastic film in its own right, but soundtrack, though featuring brilliant songs, had only a handful of previously unreleased tracks on it and was by the most part another hits collection. Still, those songs always deserve another listen.

There are even more compilations out there too, like the long deleted 4 CD set entitled simply, and rather unimaginatively at that, Lennon. There's the remastered boxed set, Gimme Some Truth, the expensive Signature Box with all his solo albums in it, the brief Icon which only has 11 random classic tracks, and several other loosely themed compilations, the weirdest of which is Peace, Love and Truth, which brings together all their songs for peace.

So what to go for? Well, Shaved Fish is brilliant (especially in its original vinyl format) and the Anthology boxed set is a never ending source of wonderment. Other than that, you're best sticking to the studio records, where John is clear as day in all his glory, forever and ever, as he himself intended.

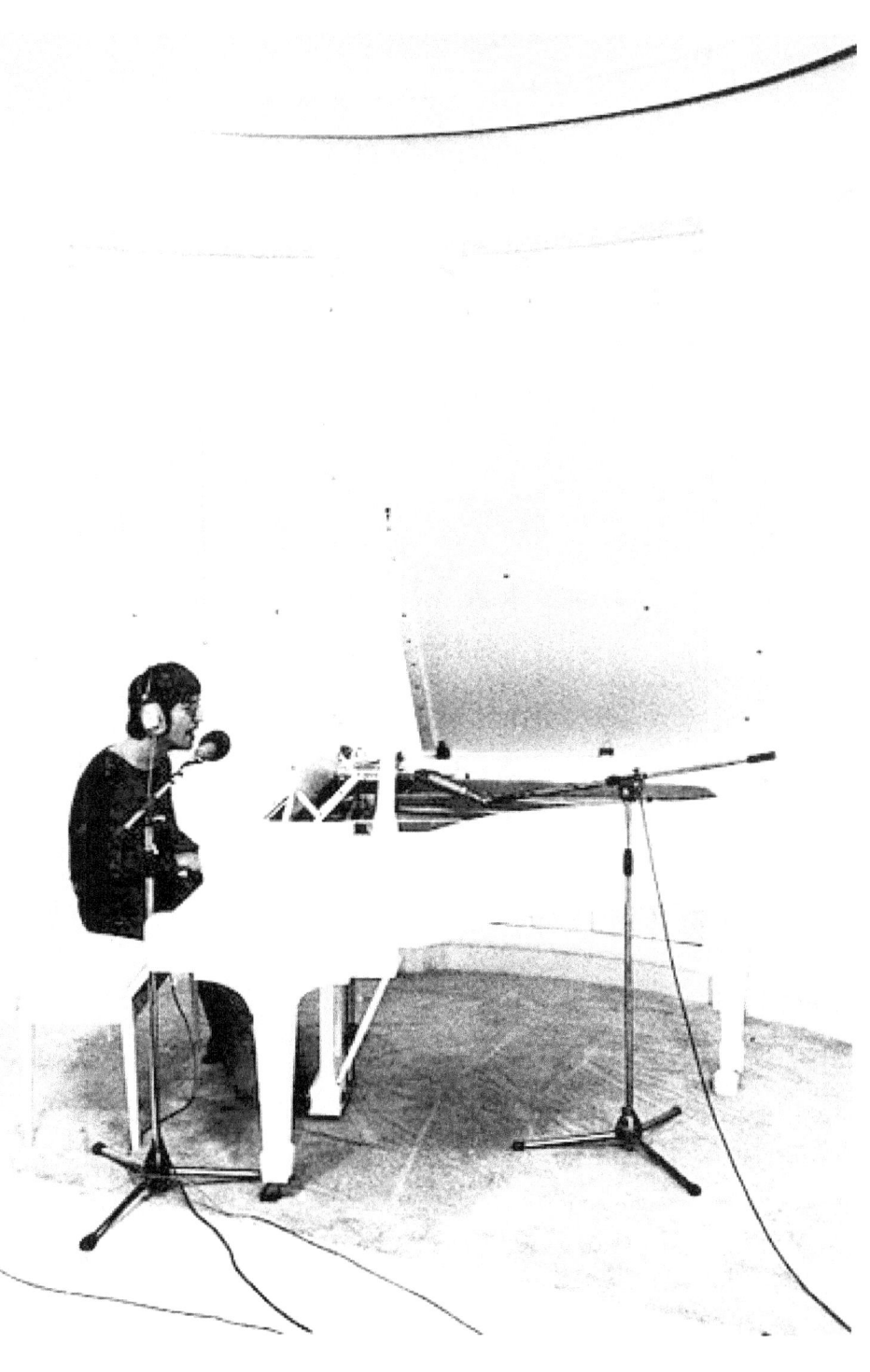

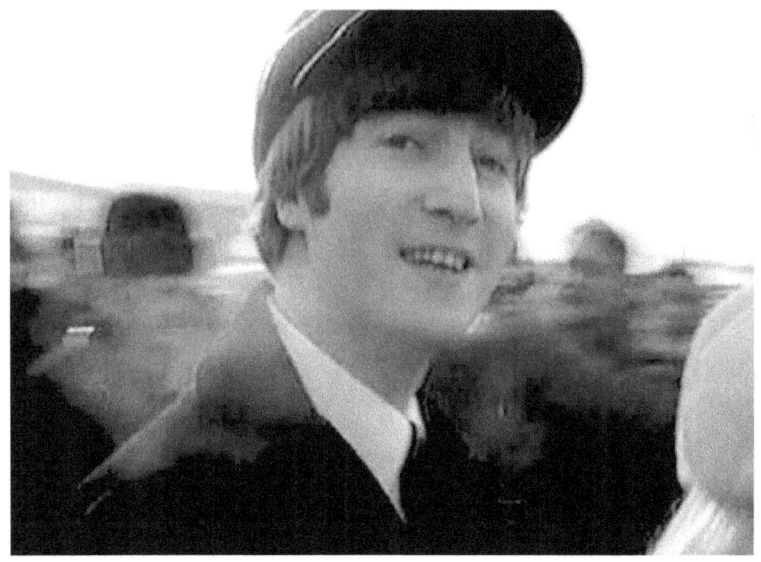

POSTSCRIPT: THE LENNON LEGACY

When watching footage of Lennon in his prime, it's hard to accept and look past his brutal fate, to swallow the fact he was taken from us so long ago, when so young and full of optimism. It's actually heart breaking when you consider what he represented to so many people, that his life force could have been snatched from him so savagely, so meaninglessly and so utterly unfairly. McCartney called his killer, whose name I will not mention, "the jerk of all jerks."

Yoko continues to relentlessly guard John's musical and personal legacy, elevating him even further as an icon and legendary figure. While Paul is undoubtedly gutted by his old friend's death and the fact he hasn't been here among us for nearly as long as he was

actually on the earth, his views on Lennon have differed over the years. Recently, to Esquire, he seemed a little insensitive to say the least. "When John got shot, aside from the pure horror of it, the lingering thing was, OK, well now John's a martyr. A JFK," he said. "So what happened was, I started to get frustrated because people started to say, Well, he was The Beatles. And me, George and Ringo would go: Er, hang on, it's only a year ago, and we were all equal-ish. And post-Beatles he did more great work, but he also did a lot of not-great work. Now the fact that he's now martyred has elevated him to a James Dean, and beyond. Yoko would appear in the press and say Paul did nothing, all he did was book the studio. Like Fuck you darling!"

Bullshit aside, Lennon left us some of the finest and bravest music that's ever been recorded, a legacy we should all feel lucky to be able to dip into. The iconography is undoubtedly important in securing that legacy, but there would be no legacy at all without those songs. These are albums which reveal new layers of importance and insight as the years go by, and also as one grows and matures. Lennon is the single most personal singer there has ever been, in as much that you really get the essence of the man through his music. He's the one man, with flaws and all, that appeals to us the most. He isn't a cartoon, a black and white rock god caricature clutching his crotch; he was and is real, not some cardboard cut out to be stuck in a record shop window to remind us of another age. John Lennon's music will be important forever, it will be looked back upon and deciphered for centuries to come. As the photos fade, the ones who knew him are gone and the records crackle to dust, John Lennon will remain...

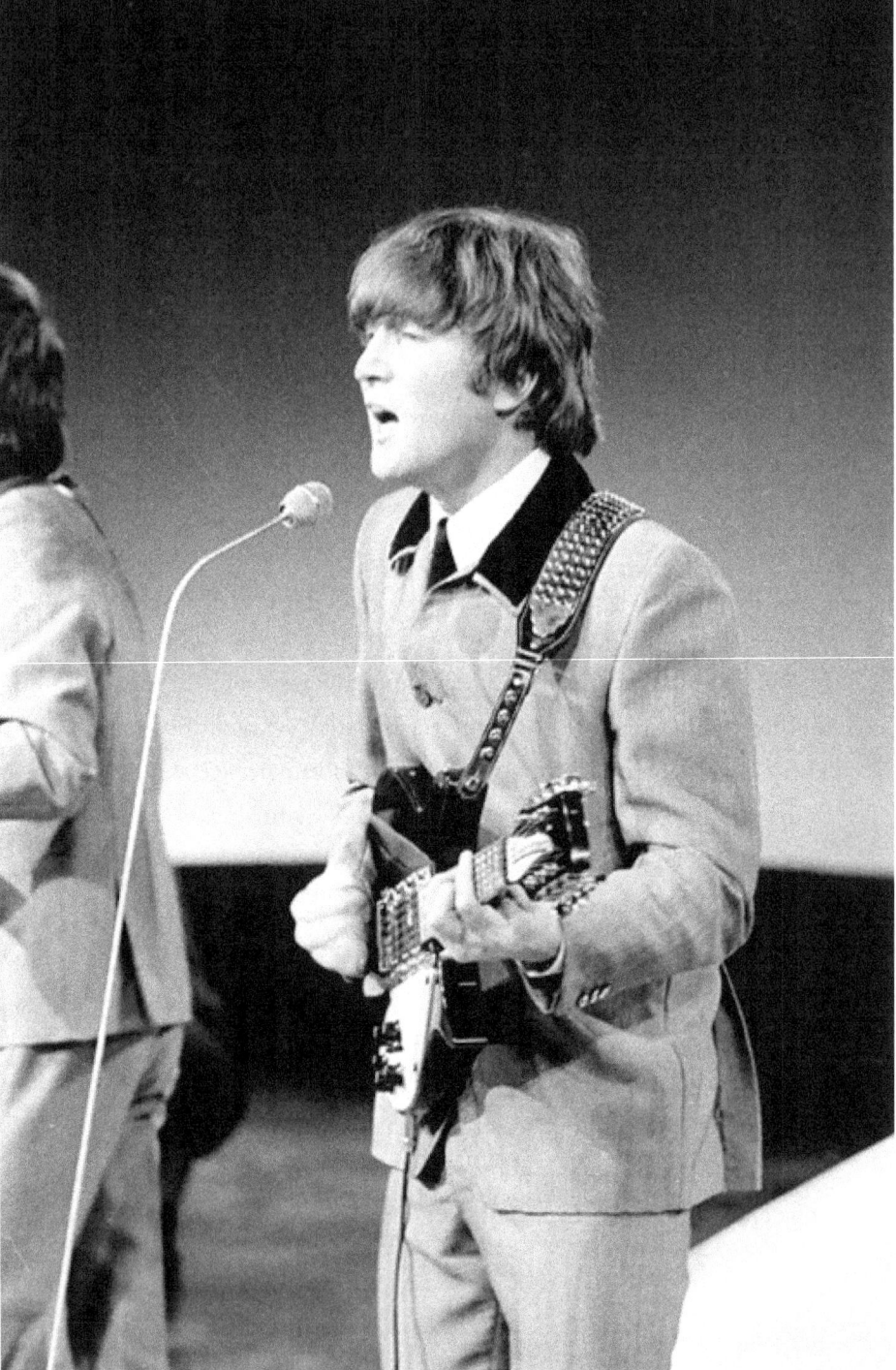

ACKNOWLEDGEMENTS AND REFERENCES

Thanks to Bill Harry, Hunter Davies, Pete Best, Julia Baird, Gary Van Scyoc, Rick Marotta, Lizzie Bravo, Ron Aprea, Gary Mallaber and Dan Richter for their recollections of John.

The following books were helpful;
Revolution in the Head by Ian MacDonald
The Beatles Lyrics by Hunter Davies
The Beatles by Hunter Davies
The Beatles Anthology Book
The Beatles Ten Years That Shook the World, Mojo Book
The Beatles: In Their Own Words
The Beatles Monthly Magazines
John Lennon in His Own Words
Remembering John Lennon
John and Yoko: The Last Interview

And these documentaries;
South Bank Show: The Making of Sgt Pepper
The Beatles Anthology
Beatles: Eight Days A Week
John Lennon Vs. The USA
John Lennon Bio
John Lennon Imagine
Gimme Some Truth

ABOUT CHRIS WADE

Chris Wade is a UK based writer and musician. As well as running the acclaimed music project Dodson and Fogg, he has written books on The Kinks, Captain Beefheart, Bob Dylan and many more. He has also released audiobooks of his comedic fiction, narrated by such actors as Rik Mayall. His other projects include Rainsmoke, a musical outfit with actor Nigel Planer, and Hound Dawg Magazine.

More info at his website: wisdomtwinsbooks.weebly.com

www.ingramcontent.com/pod-product-compliance
Lightning Source LLC
Chambersburg PA
CBHW060847170526
45158CB00001B/269